IMAGES
of America

SOUTH
ORANGE

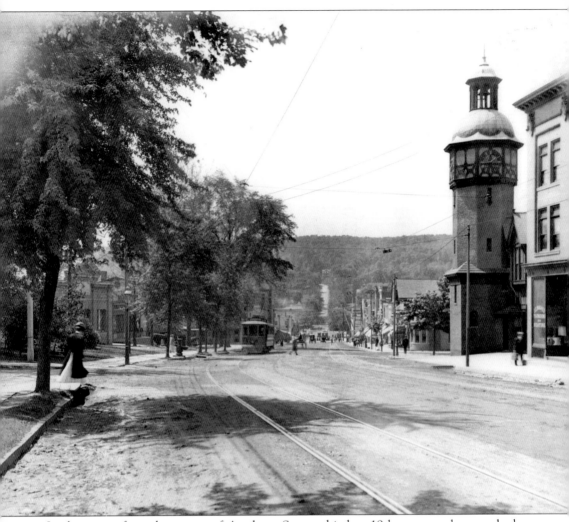

Looking west from the corner of Academy Street, this late-19th-century photograph shows South Orange Avenue. The woman in the long dress appears to be hurrying to catch the trolley. The overhead wires served as the power source for the trolley. At this early date, the train tracks crossing South Orange Avenue have not yet been elevated.

IMAGES
of America

SOUTH ORANGE

Naoma Welk

ARCADIA

First printed in 2002.

Published by Arcadia Publishing,
an imprint of Tempus Publishing, Inc.
2A Cumberland Street
Charleston, SC 29401

Printed in Great Britain.

Library of Congress Catalog Card Number: 2001096946

For all general information contact Arcadia Publishing at:
Telephone 843-853-2070
Fax 843-853-0044
E-Mail sales@arcadiapublishing.com

For customer service and orders:
Toll-Free 1-888-313-2665

Visit us on the internet at http://www.arcadiapublishing.com

This book is dedicated to my father, Vincent Barth, a fine writer who encouraged my literary pursuits. His published words continue to set lofty goals to which I continually aspire.

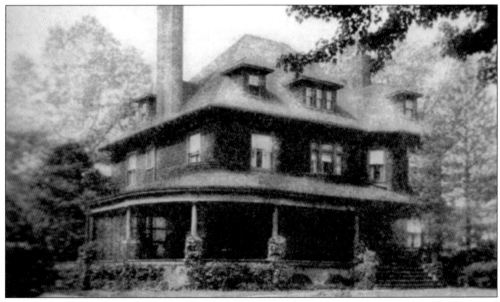

Built in the Montrose Park Historic District, this 1885 Queen Anne Victorian was the home of H.P. Findlay. It was one of the first houses built on Hartford Road. By 1911, it was home to the Arthur Schwartzenbach family. It was included in the South Orange Neighbors house tour *c.* 1977.

CONTENTS

ACKNOWLEDGMENTS

The spark that ignited this project was found in Amy Dahn, president of the Montrose Park Historic District Association (MPHDA). Her vision, energy, and ability to keep the project moving inspired me to keep writing on schedule. In addition to my own research, Amy provided a wealth of important information. Her contributions have made the book the best it can be. She has been a supportive researcher, editor, and project partner and is a significant contributor to this book.

I am fortunate to have the support of community members who are dedicated to preserving the history of South Orange. The archivists, historians, and experts who shared their photographs, time, and expertise have made it possible for readers to experience the lively history of South Orange.

I offer special thanks to Elaine Clark and the staff at the South Orange Public Library. I extend my thanks to Art Klimowicz, who dedicated hours to confirming facts and unearthing key information. My gratitude goes to Seton Hall University archivist Alan DeLozier, who shared his personal time and the university's extensive collection. James Lewis, archivist at the New Jersey Historical Society, provided key images. Anthony Vecchio of the South Orange Fire Department shared his photographs and in-depth knowledge. Nancy Heins-Glaser was generous in sharing her photograph resources and historical information. Thanks go to Leonard DeGraaf at the Edison National Archives; James Robertson, assistant university librarian at New Jersey Institute of Technology; Susan Jacobson at the Orange Lawn Tennis Club; Carleton B. Riker Jr. and Martha Riker Trundle; the Zuzuro family; Gates Helms; and Larry Lauth, who contributed expertise and oral histories. Contributing experts include Alan Angele, Mark Lerner, and Mark Yawdoszyn. MPHDA members who provided extensive detective work include Rachelle Christie, Holly Gauthier, Rayna Pomper, Kathy Ramshaw, Judy Runciman, Roy Scott, and Bill Webster. The generosity, interest, and support of countless residents helped make this book possible. To those who shared their wonderful images, recognition is given at the conclusion of each caption.

Special thanks go to my husband, Stephen, who scanned hundreds of photographs, helped organize the project, and provided endless support. He contributed enormously to this book, which brings the history of South Orange alive.

INTRODUCTION

For centuries, Native Americans traveled through what is now South Orange over a system of trails and paths. South Orange Avenue was one of the main Native American trails that led from Newark to Morristown. The early inhabitants had views of mountains, forests, and a few cultivated fields on journeys through the area. By the 17th century, they were beginning to share their land with new immigrants and a changing infrastructure.

In 1666, Puritans sailed into Newark from Connecticut under the leadership of Capt. Robert Treat and Lt. Samuel Swaine and immediately established a settlement. Documents dating from 1667 and 1668 reveal that early settlers successfully negotiated with the Hackensack branch of the Lenni Lenape tribe to purchase a large area of land that included South Orange, beginning at the Passaic River in Newark. By the time of the American Revolution, South Orange included a few farmhouses, a small stone schoolhouse, a blacksmith's shop, a gristmill, a general store, and a tavern.

An increase in residents created a demand to establish a name for the community. Several names were proposed, including Orange-field. The name Orange struck a popular chord, and it was suggested that the locality was both mountain and valley and that the name Dale would be appropriate. That name was approved. In 1782, a public meeting at the Presbytery Orange Dale was noted as the meeting site. On May 24, 1783, a notice advertising the availability of classrooms was posted and signed by Jededia Chapman.

In 1806, Orange became a separate township under an act passed by the state legislature. The first record of South Orange is in 1798, eight years before it split from Newark as a separate township. The division officially took place on May 9, 1806, at a meeting at Samuel Munn's house in Orange. At this time, the boundary lines were established. *Gordon's Gazetteer* (published c. 1830) describes South Orange: "A village of the same township lies on the turnpike from Newark to Morristown, 5 miles west of the first; it contains about 30 dwellings, a tavern and store, a paper mill and Presbyterian church; the lands around it are rich and well farmed."

The township of South Orange included a large amount of unimproved property. In order to enable those who had made extensive improvements to manage their own affairs, a village charter was obtained on March 25, 1869, when the state legislature adopted an act to incorporate the village of South Orange, in the county of Essex. The 150-acre area now known as Montrose Park was annexed to the village of South Orange on February 10, 1891. Thomas S. Kingman was instrumental in developing this area of South Orange.

The proximity of the village to major seaports and early ports of immigration made it a

natural landing site for a diverse population that mirrored the country's evolving influx of immigrants. From its beginnings, South Orange has been a diverse neighborhood, including people of various religious, cultural, and racial backgrounds. The beauty of the area was appealing in the early years, and it remains an attractive community that entices visitors to become residents. Today, South Orange presents a mix of people from all walks of life. The diversity of South Orange's population makes it one of the most interesting and unique communities in the state. As diverse as the residents may be, they exist as one unit that is devoted to a strong educational and value system for its children, a safe, friendly neighborhood for its independent seniors, and a cohesive community base that works together to preserve South Orange's past and build its future.

One

THE EARLY YEARS

The arrival of the railroad in the 19th century launched the evolution of South Orange from a small agricultural community to a suburban community. In 1837, the Morris & Essex line began serving South Orange. The following year, the railroad launched service between Newark and Morristown. The trip from Morristown to Newark took nearly three hours; today, it takes about 40 minutes. The railroads attracted new residents and, as the population grew, so did the need for public services.

In 1841, the first post office opened in John D. Freeman's general store on South Orange Avenue and served about 30 farmhouses. Income was so low (less than $50 per year) that business was suspended until 1843, when Pres. John Tyler commissioned the post office to be reestablished. In 1864, William J. Beebe, a New York tea merchant, invited friends into his home on Scotland Road to present his plan to start a library. At the close of the first year, the 139 annual members had access to 567 volumes and 24 newspapers and magazines. From 1867 until 1884, the upper floor of Smith & Lum's store was used solely as a library. The South Orange Avenue/Sloan Street location of the library seemed appropriate because the store below served as a bookseller and printer. In 1884, the library moved to the second floor of Beck's Hardware and had a budget of $700.

On August 23, 1890, the renowned Mountain House Spa (then owned by Samuel Lord, of the Lord & Taylor department store) burned to the ground. In response to this tragedy, a fire department was organized in 1891 to replace what were spontaneous volunteer brigades. Three fire companies—South Orange Hook & Ladder, Hose Company No. 1, and Hose Company No. 2—were established with 45 volunteers, hand-drawn reels, and a hand-drawn hook and ladder. The local fire commission paid $5 to stable owner Philip Detrick, who kept the horses on his property. The era of change drew to a close with the 1898 preliminary plans for the installation of a sewer system. Completed in 1904, this 23-mile trunk sewer project was a notable achievement and was deemed an important sanitation and health improvement.

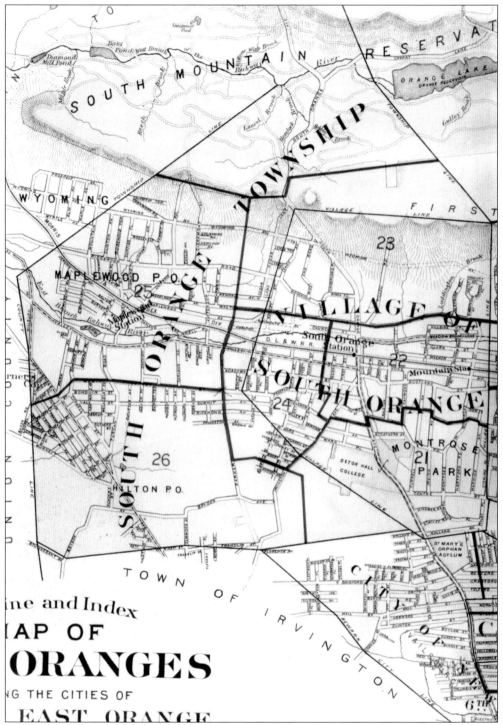

This c. 1911 map shows South Orange Township, incorporated in 1869, the village of South Orange, and part of the South Mountain Reservation. (Courtesy Amy Dahn.)

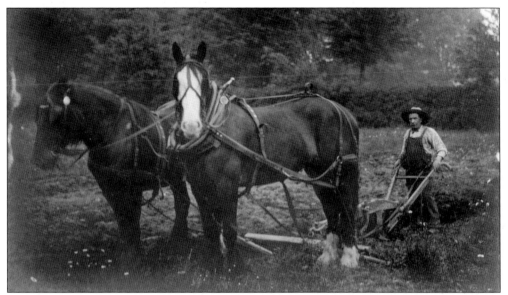

In 1899, the land on which Seton Hall University now stands was still a farming community, where farmers tended to crops and livestock. Benny Savage, shown working on the Seton Hall farm, left a portion of his estate ($10,719.83) to Seton Hall at his death in 1934. It was the college's first major bequest. Today, planned gifts are recognized by Seton Hall's organization, the Benjamin Savage Society. (Courtesy Seton Hall University Special Collections and Archives Center.)

Built in 1774 by the Squire family, this homestead on the Squire Farm was purchased by William Redmond in 1850. His purchase included a large tract of land extending from Ridgewood Avenue to the top of the mountain. Redmond enjoyed horses and was the first to introduce Jersey cows to this section of the country. Redmond built Hillside, a large brownstone mansion, which in its day was considered one of the finest in this part of the country. His wife died in March 1870, and Redmond died on September 13, 1874. The mansion remained in the family until it was sold in 1916 and became the clubhouse for the Orange Lawn Tennis Club. (Courtesy South Orange Public Library.)

Born in 1825 in Fairfield, Connecticut, George Benedict Turrell built a career in manufacturing. In 1888, he purchased a farm and raised Jersey cows in Sussex County, New Jersey, where he developed a system of cooling and aerating milk so that it could be bottled and shipped within 20 minutes after milking. This was such an improvement over the standard 12-hour process that his milk brought double the price received by other milk producers. In 1874, he recommended a system of road making described as "construction by repairs," saving the village nearly $5,000 per mile. The Turrell system was adopted by the village and implemented as new roads were created in town.

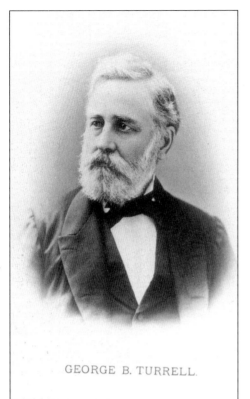

GEORGE B. TURRELL.

In 1892, successful merchant Thomas Sewall Kingman moved to South Orange, built a beautiful mansion on Elliot Place, and subsequently pioneered the development of a 150-acre area known as Montrose Park. He joined William F. Havemeyer and other capitalists who formed a syndicate for the purposes of improving and developing Montrose Park. Their goal was to provide beautiful homes for wealthy men who had neither the time nor inclination to attend to the details of building.

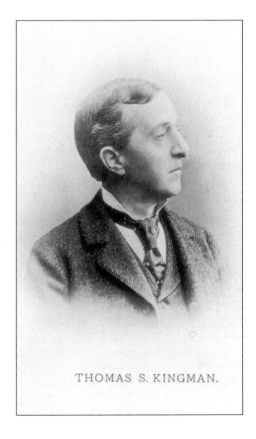

THOMAS S. KINGMAN.

12

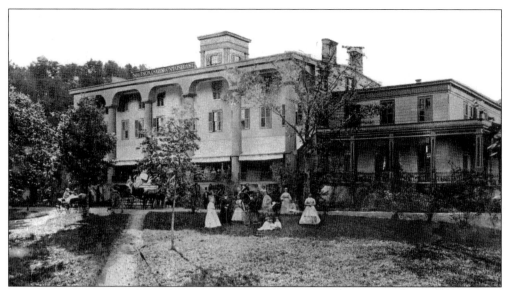

Mountain House Spa, located on Ridgewood Road at the foot of Glenside Road, was a fashionable water-cure hotel built *c.* 1830. The hotel accommodated 150 guests and was supervised by two physicians, Dr. O.W. May and Dr. O.H. Wellington. Unfortunately, the wood-framed hotel burned to the ground in 1890. Today, the only reminders of the once famous resort are Mountain Station and Mountain House Road, both of which were established to accommodate the large volume of visitors who flocked to South Orange. (Courtesy South Orange Public Library.)

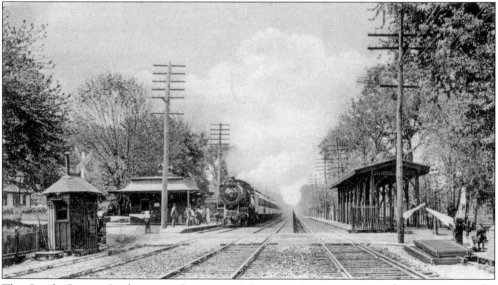

The South Orange Lackawanna Station, at Montrose Avenue, conveyed passengers on the Morris & Essex line of the Delaware, Lackawanna & Western Railroad between New York and points west, including two stops in South Orange. This station was originally known as the Montrose Station but later became known as Mountain Station because it was the closest station for passengers traveling to the Mountain House Spa. Horses would bring carriages to this station to collect spa guests and their large trunks. (Courtesy Seton Hall University Special Collections and Archives Center.)

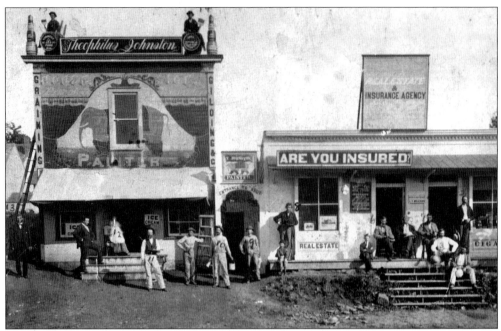

In 1868, Theophilus Johnson's house and sign painting company was located on Sloan Street. On his building, he claims to specialize in gilding and graining. Johnson's advertisements can be found in nearly every 1871 issue of the *South Orange Bulletin*. In that era, houses (especially shingle houses) were primed with linseed oil, which would sink into the wood for protection and serve as a base for oil paint. These men are seated on the roof of Johnson's store above barrels of pure linseed oil and pure turpentine. An insurance office run by village clerk Joseph Wildey was also at this location. (Courtesy Tom Riccardi.)

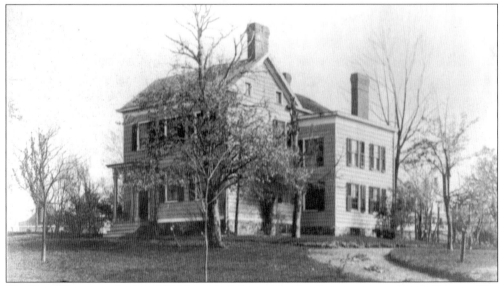

The Riggs House was built *c.* 1826 by one of the earliest families to come to South Orange. The Riggs family dates from the early 1700s, when a reference is made to "an other Road from said Road South by a line of mark'd trees to Joseph Riggs' House." This description refers to what is now Ridgewood Road. (Courtesy South Orange Public Library.)

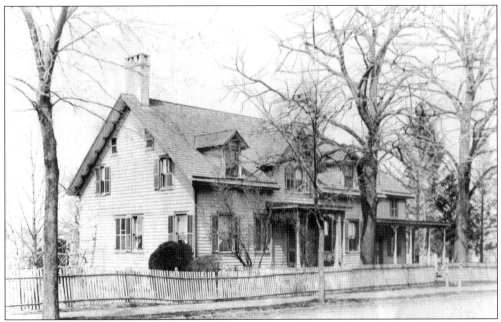

The Jeptha Baldwin Homestead, located at 311 Centre Street (at the corner of South Orange Avenue), is shown in this April 18, 1896 photograph. The house was built *c.* 1760 by the Baldwin families. Additions to the original house were made *c.* 1770 and 1800, and renovations were completed during the Victorian era. This 11-room home still stands and includes five bedrooms, three full baths, and seven fireplaces. (Courtesy South Orange Public Library.)

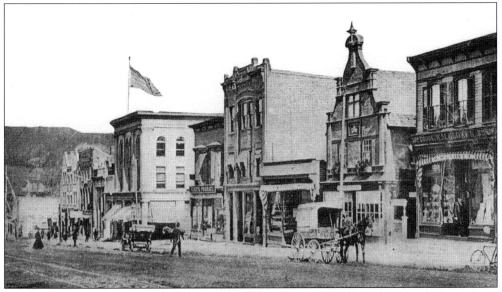

This early photograph of South Orange in the late 1800s shows a bustling town with early signs of sophistication. Both an automobile and a horse-drawn carriage share space on South Orange Avenue. From the center of town, looking west, one can see mountains and an undeveloped landscape. Farms rather than villages dotted the outlying landscape at this time. (Courtesy Seton Hall Special Collections and Archives Center.)

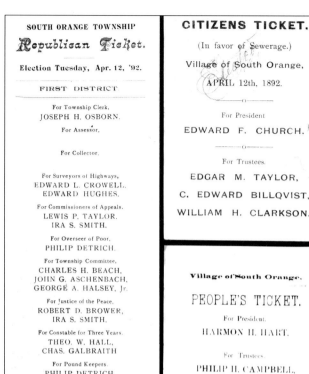

SOUTH ORANGE TOWNSHIP	CITIZENS TICKET.	South Orange Township
Republican Ticket.	(In favor of Sewerage.)	**DEMOCRATIC TICKET**
Election Tuesday, Apr. 12, '92.	Village of South Orange,	Election, Tuesday, April 12. 1892.
FIRST DISTRICT	APRIL 12th, 1892.	FIRST DISTRICT.
For Township Clerk, JOSEPH H. OSBORN.		For Township Clerk, JOSEPH H. OSBORN.
For Assessor,	For President	For Surveyors of Highways, JOHN WELSHER, CAREY J. HEADLEY.
For Collector,	EDWARD F. CHURCH.	For Commissioners of Appeal, CHARLES I. BECK, ROBERT LESLIE.
For Surveyors of Highways, EDWARD L. CROWELL. EDWARD HUGHES.	For Trustees. EDGAR M. TAYLOR,	For Overseer of Poor, WILLIAM B. NEWMAN,
For Commissioners of Appeals. LEWIS P. TAYLOR. IRA S. SMITH.	C. EDWARD BILLQVIST, WILLIAM H. CLARKSON.	For Township Committee, JOHN V. DIEFENTHALER, HUGH CONLAN, ALEXANDER MELVILLE.
For Overseer of Poor, PHILIP DETRICH.		For Justice of the Peace, LOUIS ALBECK, JOHN O'REILLY, Sr.
For Township Committee, CHARLES H. BEACH, JOHN G. ASCHENBACH, GEORGE A. HALSEY, Jr.	**Village of South Orange.** PEOPLE'S TICKET.	For Constables, LEWIS H. SMITH. For 3 years, JOHN J. NEWMAN, For 3 years
For Justice of the Peace, ROBERT D. BROWER, IRA S. SMITH.	For President. HARMON H. HART.	For Pound Keepers, ALEXANDER VOLHEYE, TIMOTHY BURNETT,
For Constable for Three Years. THEO. W. HALL, CHAS. GALBRAITH	For Trustees. PHILIP H. CAMPBELL,	GEORGE SCHMIDT.
For Pound Keepers. PHILIP DETRICH.		For Township Purposes . . . $2,000 00

Four political parties promoted their candidates in the April 12, 1892 election: the Republican, Citizens, People's, and Democratic parties. This ballot notes that the Citizens ticket won the election based on their favoring a sewer system, a paramount concern of that time. Also of note is the fact that many of these candidates were volunteers in the South Orange Village Fire Department. In addition to their traditional duties, the fire department was a social organization and part of the political process. Often a prerequisite for a political office was membership in the fire department. (Courtesy South Orange Village Hall.)

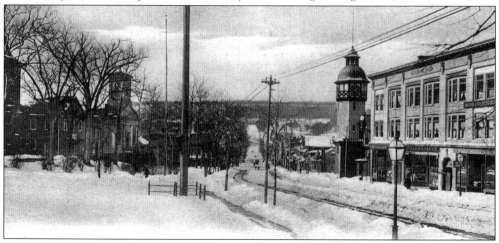

This postcard of winter in South Orange was sent on September 28, 1909, to Polly Osborne of New York City. The message reads, "Do not forget to be at services at 10:30 Wednesday. Wrote other postal yesterday. A.G.O." A mix of overhead power lines and gaslights suggest a town that is focused on keeping the old while bringing in the new. (Courtesy Amy Dahn.)

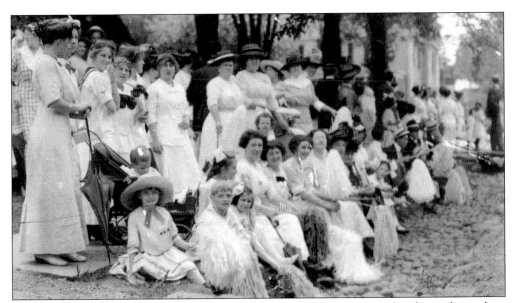

These men, women, and children, pictured *c.* 1915, gather on a triangle of grass located on Irvington Avenue at South Orange Avenue for what appears to be a passing parade. Although they are sitting on the grass with their legs in the cobblestone gutter, the women and children are decked out in summer finery of light-colored street-length dresses and straw hats. Umbrellas are carried to protect their faces from the hazardous rays of the sun. A small child sits in a pram. (Courtesy South Orange Public Library.)

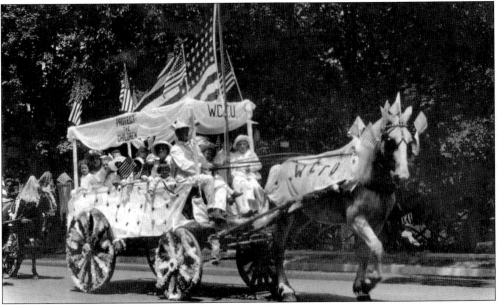

Determined to protect citizens from the evils of alcohol, the Women's Christian Temperance Union began in 1879 and appears to be alive and well in this 1915 Independence Day parade, traveling east on South Orange Avenue. The float, decorated in 48-star flags and flower-covered wheels, carries virtuous women, innocent children, and one man to handle the reins. Mary Stiles Halsted Hathaway sits front and center. (Courtesy Seton University Special Collections and Archives Center.)

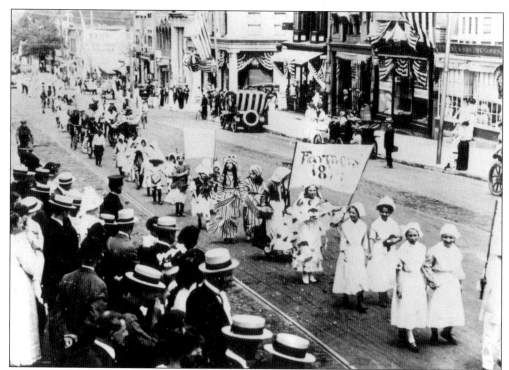

Dressed as nurses and wearing Red Cross arm bands, these four women participate in the 1915 Independence Day parade, which prompted South Orange enthusiasts to deck their retail stores and cars in red, white, and blue bunting. (Courtesy South Orange Public Library.)

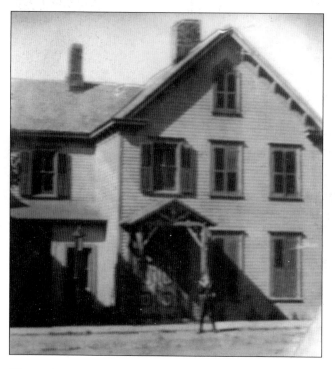

A young boy wearing a sailor suit stands in front of 15 Valley Street, the old Marcus Ball homestead, and the village's first community house. In about 1918, the Society for Lending Comfort to the Sick was housed and operated by local society women who offered health services and shelter to needy women and children. This community house was integral to the survival of women left behind when their husbands went to war and was popular during the 1918 flu epidemic, when medical attention was in great demand. (Courtesy South Orange Public Library.)

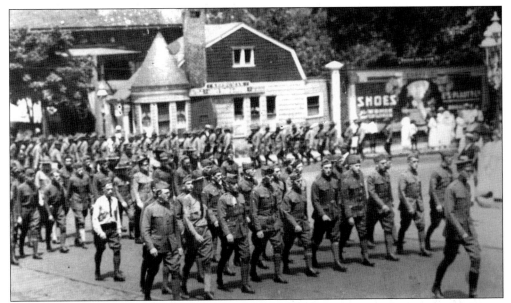

Women in white street-length dresses and men in straw boaters enjoy the summer afternoon parade of World War I soldiers marching in formation. Proceeding south on Scotland Road, the soldiers would turn left and travel east on South Orange Avenue as they approached the reviewing stand in front of the village hall. (Courtesy Tom Riccardi.)

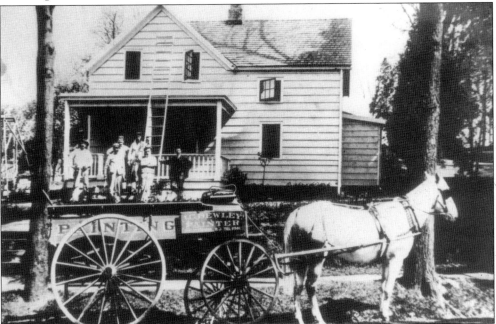

The local firm of J.C. Hewley painters freshens up the 1880 home of Mr. and Mrs. Fred Ardrey at 114 Prospect Street. Fred Ardrey was an undertaker who served the Methodist Episcopal church, located just a block and a half away. The 1904 town map shows that Ardrey owned adjoining lots. One lot has a shed; this lot has a house and large stable. The stable housed horses and carts that could carry caskets from the house (where viewings would be conducted) to the church and on to the cemetery. (Courtesy Tom Riccardi.)

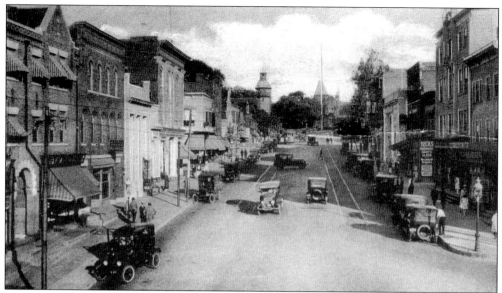

In this *c.* 1920 photograph, the tower of the village hall is one of the tallest structures seen. Delivery carts and personal carriages hug the curbs while the trolley takes over the center of the street. Wallace's Newspapers, seen on the left with the folded awning, hired newspaper boys to deliver morning, afternoon, and Sunday papers. (Courtesy Seton University Special Collections and Archives Center.)

Pictured *c.* 1880, Sgt. Edward A. Tracey stands beside the 1873 police headquarters and four-cell jail, which was erected a year after the police department was organized. Henry Trenchard, appointed marshall on April 15, 1872, was provided with a bicycle and a salary of $50 per month. Reports from 1892 indicate there were 80 arrests (75 men, 5 women) for the year: drunk and disorderly (60), hitching to trees (4), vagrancy (9), and suspicion (7). Of those arrests, 29 were committed to county jail and 32 were discharged. Fines totaled $138. (Courtesy South Orange Public Library.)

Two

TRANSPORTATION

Transportation has been an important ingredient in the growth and development of South Orange. The village's bucolic surroundings, close proximity to New York City, and excellent public transportation schedules have made for an attractive formula for South Orange residents for nearly 125 years.

In the early years, South Orange was viewed as a getaway destination from large cities. Mountain air was considered to have life-giving currents, and South Orange was far removed from the lowlands of the cities. When the Morris & Essex Railroad came through the area in 1836, it became possible for wealthy New York City and Newark businessmen and their families to spend the summer months in South Orange and the surrounding area.

Dependable rail service and expanding train schedules in the 1850s contributed to the population migration from Newark (as well as many other industrialized cities across the country) to outlying areas, including South Orange. The beauty of the area and the new transportation link to both Newark and New York impressed John Vose, who began buying tracts of land with an eye toward developing the area. Vose became involved with the Newark, Montrose & South Orange Horse Car Railroad Company and served as its president. The company provided service along South Orange Avenue and connected the village to downtown Newark and the Oranges. This service and the Morris & Essex Railroad connection with New York became an essential factor in the suburban migration to South Orange.

An important contributor to the railroad industry was William Frederick Allen. Allen was the editor of *The Official Railway Guide* in 1869 and, in 1875, was elected permanent secretary of the Railway Time Convention (subsequently the American Railway Association). The railroad industry drove the need for a method of standardizing time, and Allen led the way in implementing a successful system. *The Founders and Builders of the Oranges* (1896) states, "Mr. Allen has achieved a world-wide reputation in his successful efforts to perfect and secure the adoption of the system of Standard Time now in general use throughout the civilized countries of the world. . . . Numerous schemes had been proposed. . . . But none of them were so well defined as to admit no doubt of their successful operation."

By the 1890s, professional businessmen preferred to locate their families in the suburbs and travel to the city for business. The development of South Orange as a commuter suburb was about to begin.

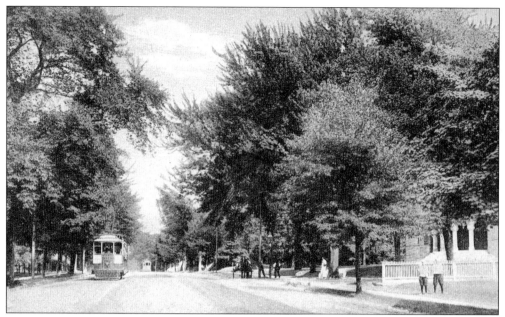

In the decade following the Civil War, a young New York lawyer, John Gorham Vose, began spending his summers in Orange Valley. Vose developed much of the former farmland of South Orange and served as the president of the Newark, Montrose & South Orange Horse Car Railroad Company. (Courtesy Amy Dahn.)

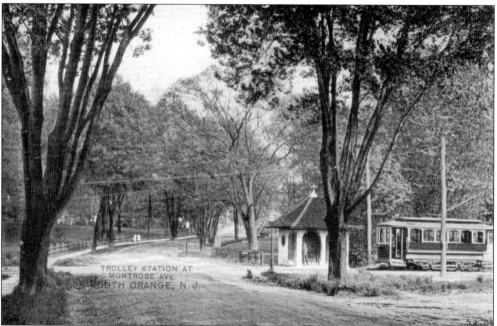

A trolley stops at the Montrose Avenue station at Meadowbrook Lane in 1908. This postcard, addressed to a Ms. Strunk in Monroe County, Pennsylvania, asks several questions: "Dear Sister. What have we ever done to you? Will you let me know? Did I make you mad? I would not for the whole world. Sadie Shott." (Courtesy Seton Hall University Special Collections and Archives Center.)

From May 1837 to 1838, the Morris & Essex Railroad featured its summer schedule of three scheduled trips between Newark and Morristown. The company required two engines (the *Morris* and the *Essex*) to pull the trains. The fare from Morristown (the farthest point) to Newark was 75¢. From Orange (the closest point) the fare was 12.5¢. (Courtesy Mark Lerner.)

MORRIS & ESSEX RAILROAD.

THIS road was chartered January 29th, 1835, and the Company commenced running their Cars by horse power from Newark to Orange November 19th, 1836; from Newark to Madison by steam power on Monday the second of October, 1837; and from Newark to Morristown on the first day of January, 1838. The average daily receipts from Newark to Morristown (for passengers) from first of January to first of May, has been $72. An eight wheel Car, capable of carrying from seventy to one hundred passengers, was placed on the road the 15th February, 1838, and a second engine was put on the road in May, 1838. The Cars now leave Newark and Morristown three times a day. The road has also been surveyed from Morristown to Easton, and is expected to be under contract this summer—and from thence to Carpenter's Point.

Summer Arrangements.

Leaves Newark 6¼ A. M.	Leaves Morristown 6¼ A.M.
" " 10 "	" " 1¼ P.M
" " 5 P. M.	" " 5 "

Fare.

Newark to Orange	12½	Newark to Chatham	50
" S. Orange	25	" Madison	62½
" Millville	31¼	" Morristown	75
" Summit	44		

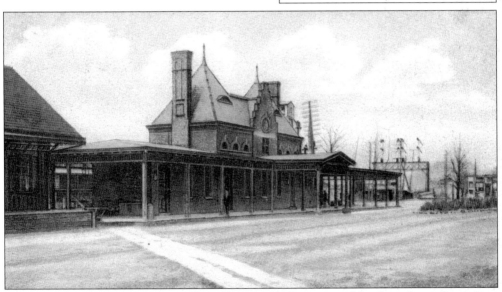

The first trains began stopping in the village in 1837 on ground-level tracks, such as those shown. The need to eliminate dangerous pedestrian crossings and streamline grades along the tracks resulted in a proposal to elevate the tracks at South Orange. In 1914, construction began. In the fall of 1915, the new station and elevated track project was completed. The cost to the town was $23,000 and, to the Lackawanna Company, about $1 million. (Courtesy Seton Hall University Special Collections and Archives Center.)

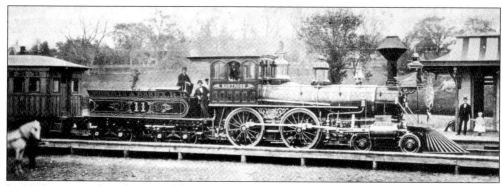

In 1868, prior to the takeover of the Morris & Essex Railroad by the Delaware, Lackawanna & Western, the Morris & Essex purchased this locomotive, *Montrose* (No. 11). The engine is shown at Montrose Avenue at its namesake station, later named Mountain Station. In 1883, the locomotive received a new boiler and larger cylinders. After 35 years of service, *Montrose* was retired from service. (Courtesy South Orange Public Library.)

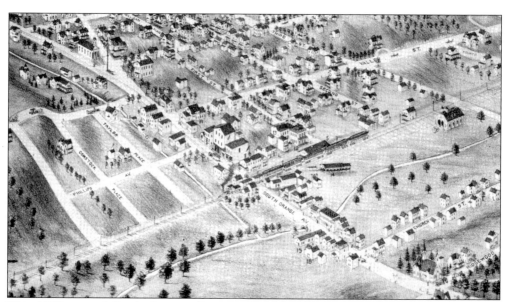

This 1877 map of South Orange illustrates that there had been an extensive increase in population during the 19th century. (Courtesy Amy Dahn.)

FROM NEW-YORK.

STATIONS.	S. Orange Accom.	S. Orange Accom.	Through Mail	Summit Accom.	Through Freight	Dover Freight	S. Orange Accom.	Summit Accom.	Through Mail	S. Orange Accom.	Morris'n Express	S. Orange Accom.	Summit Accom.
	A.M.	A.M.	A.M.	A.M.	A.M.	P.M.	P.M.	P.M	P.M.	P.M.	P.M.	P.M.	P.M.
New-York, f't Barclay St		7.30	8.20	11.30		1.00	2.30	3.40	4.10	4.30	5.00	5.30	6.30
Hoboken		7.45	8.45	11.45	11.35	1.15	2.45	3.55	4.25	4.45	5.15	5.45	6.45
Newark	6.45	8.11	9.10	12.10	12.15	1.45	3.10	4.20	4.50	5.10	5.40	6.15	7.10
Bloomfield Junction	6.54†	8.19†	9.16†	12.18†	12.21†	1.54†	3.18†	4.28†	4.56†	5.18†	5.45†	6.23†	7.18†
Orange	7.03	8.27	9.22	12.26	12.34†	2.15	3.28	4.38	5.01†	5.28	5.50†	6.33	7.28
South Orange	7.12	8.35	9.28	12.34	12.43†	2.31	3.35	4.48	5.06†	5.35	5.55†	6.40	7.36
Millburn			9.36	12.45	12.55†	2.53		4.58	5.13†			6.02	7.46
Summit			9.46	12.58	1.10	3.20		5.10	5.22			6.11	7.58
Chatham			9.55		1.28†	3.50			5.31			6.20	
Madison			10.01		1.37†	4.08			5.37			6.25	
Morristown			10.14		2.05	4.40			5.49			6.35	
Morris Plains			10.20		2.14†	4.49†			5.55				
Denville			10.30		2.45	5.10			6.04				
Rockaway			10.35		2.55	5.25			6.09				
Dover			10.46		3.20	5.40			6.18				
Drakesville			10.57		3.50				6.30				
Port Morris			11.03'		4.00†				6.35†				
Stanhope			11.08		4.15				6.40				
Waterloo, (Sus. R. R. J.)			11.'6		4.35				6.48				
Hackettstown			11.30		5.00				7.00				
	A.M.	A.M.	A.M.	P.M.	P.M.	P.M.	P.M.	P.M.	P.M.	P.M.	P.M.	P.M.	P.M.

For Table of Trains between Newark and New-York, see 1st page.

TO NEW-YORK.

STATIONS.	Through Freight	Summit Accom.	Morrist'n Express	S. Orange Accom.	Through Mail	Summit Accom.	S. Orange Accom.	Summit Accom.	Through Mail	S. Orange Accom.	S. Orange Accom.	S. Orange Accom.	Dover Freight
	P.M.	A.M.	A.M.	A.M.	A.M.	A.M.	A.M.		P.M.	P.M.	P.M.	P.M.	P.M.
Hackettstown	8.00				6.45				1.45				
Waterloo, (S.R.J.)	8.33				6.57				1.58				
Stanhope	9.00				7.04				2.06				
Port Morris	9.15†				7.03†				2.10†				
Drakesville	9.30				7.14				2.14				
Dover	9.55				7.27				2.29				6.25
Rockaway	10.15				7.35				2.36				6.40
Denville	10.24				7.40				2.41				6.47
Morris Plains	10.42†				7.50				2.51				7.00
Morristown	11.00		7.10		8.00				3.00				7.15
Madison	11.25		7.18		8.11				3.12				7.35
Chatham	11.40		7.23		8.17				3.18				7.52
Summit	12.04	6.15	7.30		8.27	8.30		1.15	3.28				8.12
Millburn	12.26	6.26	7.38		8.37	8.40		1.27	3.38				8.32
South Orange	12.42	6.36	7.45†	7.48	8.43†	8.50	10.00	1.37	3.47	4.50	6.00	7.00	8.47
Orange	1.00	6.43	7.50†	7.56	8.48†	9.00	10.08	1.46	3.53	5.03	6.08	7.03	8.59
Bloomfield Junc.	1.10†	6.53†	7.56†	8.08†	8.54†	9.12†	10.21†	1.54†	3.59†	5.12†	6.18†	7.18†	9.07
Newark	1.30	7.00	8.05	8.15	9.00	9.20	10.30	2.00	4.05	5.20	6.25	7.25	9.30
Hoboken	2.00	7.25	8.30	8.40	9.23	9.44	10.55	2.25	4.30	5.45	6.53	7.50	9.55
New-York, due at	2.15	7.35	8.45	8.55	9.35	9.55	11.05	2.40	4.45	6.00	7.05	8.10	10.10
	A.M.	A.M.	A.M.	A.M.	A.M.	A.M.	A.M.	P.M.	P.M.	P.M.	P.M.	P.M.	P.M.

Trains do not stop at stations designated thus † except for the Company's convenience.

The Morris & Essex Railroad increased and expanded service to accommodate the heightened demand for transportation, as shown in this c. 1865 train schedule. Although some stops in South Orange were made to take on freight and mail, an annual report for 1864 shows that passenger receipts produced nearly three times the amount of revenue as did freight traffic and 40 times the amount of revenue received from mail transportation. (Courtesy South Orange Public Library.)

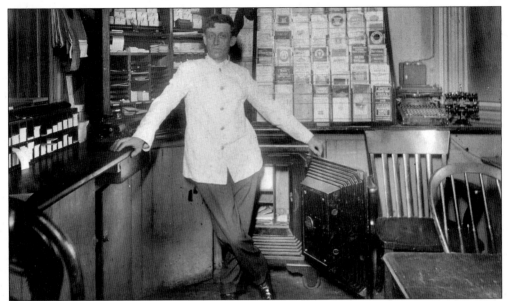

Even after telephones were in use by the railroad, ticket sellers had to know Morse code so they could take messages and train orders from the dispatchers. In this photograph, John S. Magee reveals the contents of his safe as he stands in front of ticket stock, train schedules, and a ticket date stamp. (Courtesy South Orange Public Library.)

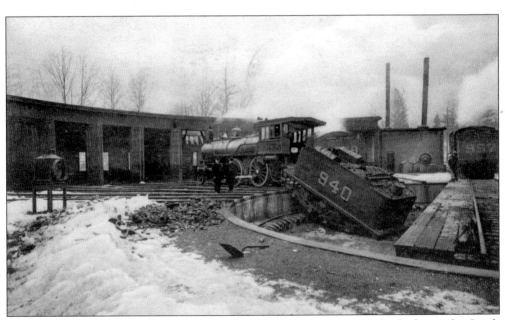

On May 1, 1906, William E. Dobbins, hostler of locomotive No. 940, backed into the South Orange turntable pit, which trapped several engines that had been scheduled to go out over the next few hours. Dobbins worked for the Delaware, Lackawanna & Western Railroad from March 8, 1904, until May 1, 1906, as a fireman but was fired after the turntable pit interruption. (Courtesy Seton Hall University Special Collections and Archives Center.)

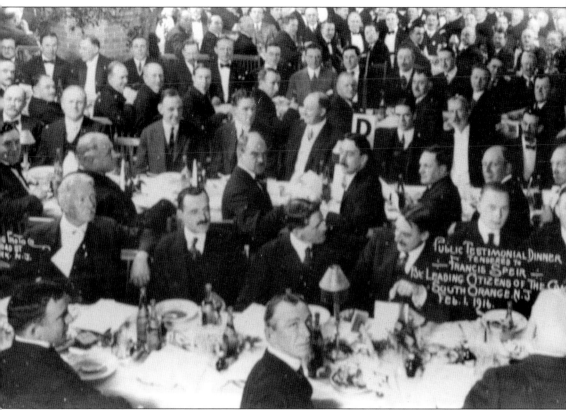

For his services to the village and his work in elevating the train tracks at the South Orange station, Frances Speir was honored on February 1, 1916, at a banquet held at the new South Orange railroad station. Speakers for the event included William H. Truesdale (president of the Lackawanna Railroad), Frances Speir, Hon. Edward D. Duffield, toastmaster Arthur B. Leach, George A. Cullen, and Maj. John V. Kilpatrick. Kilpatrick's speech, entitled "Commuting as an Outdoor Sport," illustrates the popularity of traveling by rail from the suburbs to the cities, even at that early date.

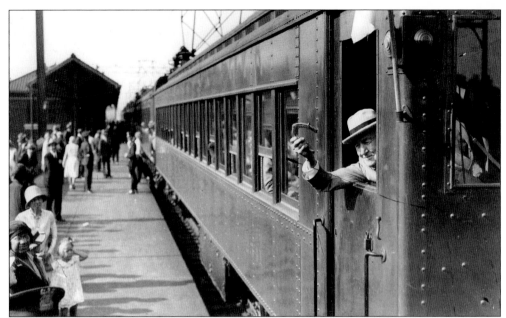

This photograph, taken on September 3, 1930, shows Thomas Edison leaning out the window of the train, showing a good-luck horseshoe to the crowd at the South Orange station. Edison drove the Delaware, Lackawanna & Western's first electrified train for the first half mile, from Hoboken to South Orange. The electrification of trains made it possible to run heavier trains that were cleaner, quicker, and able to accelerate and decelerate quite rapidly. These first electric trains were able to accelerate at the new fast time of one mile per hour per second. (Courtesy U.S. Department of the Interior, National Park Service, Edison National Historic Site.)

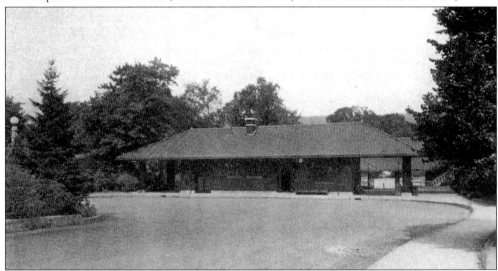

The excellent commuting conditions to New York made South Orange a popular location for businessmen to live. The September 8, 1901 issue of the *New York Daily Tribune* featured an article entitled "Proud Commuters in Jersey." The article comments on commuters at Mountain Station: "People have the reputation of being the worst 'kickers' (complainers) on the system. 'They live up on a big hill,' explained one conductor, 'and think they are the whole procession.'" (Courtesy Seton Hall University Special Collections and Archives Center.)

Three

PUBLIC BUILDINGS
AND SERVICES

Known in 1872 as "Little Switzerland" and the "Switzerland of America" for its healthful climate that combined mountain air with the ocean breeze, South Orange attracted a large population in the second half of the 19th century. Public services were needed to continue the bucolic lifestyle that originally drew tourists to the community.

Before its incorporation in 1869, the village had a public school, a library, a train station, and a post office. When someone in town needed a doctor, a white flag was posted at the train station. Telephones arrived in 1879, electricity in 1888. The fire department began in 1891. The prevalence of wooden structures, in-home gaslights, and faulty fireplace chimneys made the fire department important to the success of the town. The alarm could be heard all over town. The first thing to be done at a fire was to disconnect horses from the equipment, remove them from danger, and walk them to cool them down. A young boy assisting in the process could earn a penny.

By about 1916, horses began to retire from the department. One horse was sold to a laundry merchant next door to the fire department. When the fire alarm sounded one day, the horse broke away from his hitching post and followed the shiny new fire truck to the scene of the fire. The fire captain recorded this incident in his minutes and stated that when the firemen saw their old horse, they were moved to tears.

In 1892, the Citizens party won the election on the platform of instituting a sewer system. Over the next eight years, South Orange worked with 18 other municipalities, encompassing 66 square miles to complete the 23-mile trunk sewer project.

Other public initiatives included the famous scheme to rid South Orange of mosquitoes. In the early 1900s, the spread of malaria was a crucial health concern, and a mosquito-extermination commission was established. Bogs were drained, kerosene oil was spread on stagnant waters, and screen doors and windows became very popular. By 1903, the mosquito population had been significantly reduced. However, 18 continuous days of rain in June and another 13 rainy days in August revived the pests. Efforts were redoubled and, in 1903, the *New York Sun* and *Washington Post* recognized the village for its great reduction of mosquitoes and subsequent help in reducing the potential spread of malaria. The mosquito commission was active well into the 1920s.

Other programs that focused on health, transportation, and safety continued to make South Orange a desirable and convenient place to live.

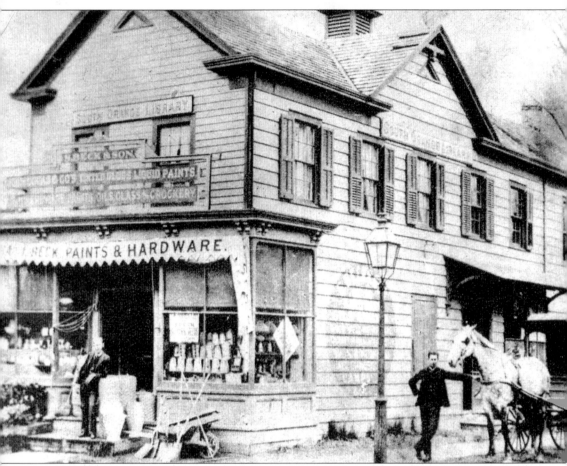

In 1884, the library was located to 75 South Orange Avenue and occupied the second floor of Beck's Hardware. The 1884 budget for the library was $700. Louise Taylor, who frequented the library as a child, recalls, "One had to climb a steep, outside, covered stairway on the left side of the building. It was a long, dark passage and was rather spooky after sunset. Inside were a few lamps, tables, chairs, books, and a librarian's desk. Miss Tate, a Scotch lady from near Montrose, was the first librarian I remember." (Courtesy South Orange Public Library.)

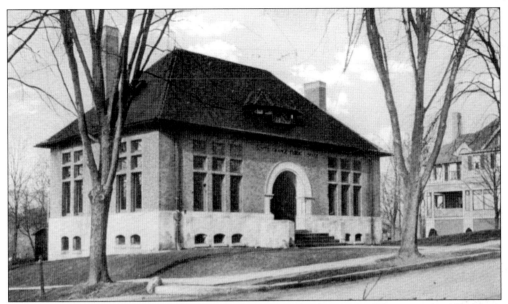

The library's expanding collection and circulation resulted in a need for a separate building. Eugene V. Connett donated land at the corner of Scotland Road and Taylor Place on the condition that the sum of $7,500 be "bona fide subscribed for the construction of a library building." On May 8, 1896, the library moved into this building, which is today known as "the old library." From its inception, some 500 families had subscribed to the library and covered all expenses. By 1916, there was talk of the need for the library to be made a truly public institution supported by taxes, which happened in 1926. (Courtesy South Orange Public Library.)

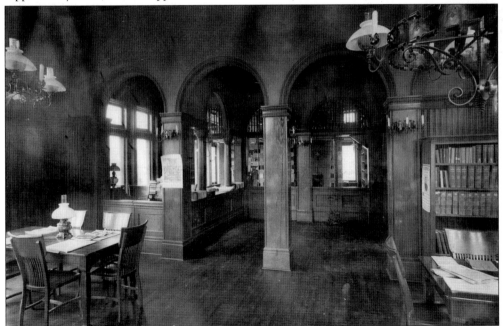

This photograph shows the interior of the 1896 library building, with beautiful wood trim and state-of-the-art lighting to enable visitors to read and conduct research. Today, this building is next to the newest library building. (Courtesy collections of New Jersey Historical Society.)

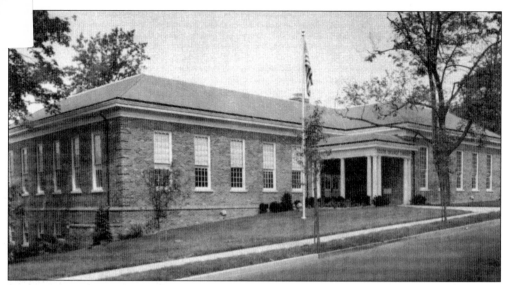

With increased circulation from 55,776 in 1926 (when the library became public) to a circulation of 155,055 in 1960, a larger library was needed. It was built at 68 Scotland Road, next door to the previous library, and opened in 1968. The budget was increased to $154,424. The building includes a children's room on the ground floor, with book stacks and a balcony on the floor above. Today, it is home to more than 90,000 books, from picture books for preschoolers to large-print books. The library maintains 230 magazine subscriptions and holds microfilm materials of the *New York Times* and the *News Record*. (Courtesy South Orange Public Library.)

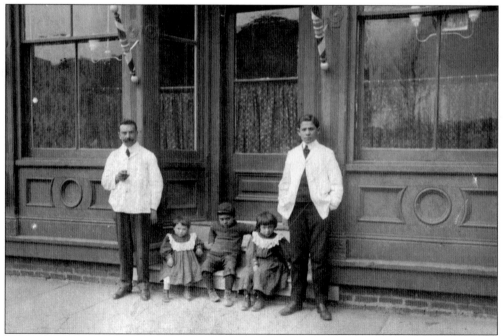

Beatrice's Barbershop was founded in 1896 on South Orange Avenue and is shown in this c. 1906 photograph. Shown from left to right are shop owner Alessandro Beatrice; his children Helen, Anthony, and Mary; and one of his employees. (Courtesy Rose and Joe Zuzuro.)

James F. Farrell joined the South Orange Village Fire Department on the day it was formed, February 2, 1891. On that date, the *South Orange Bulletin* reported, "The 'bucket brigade' has seen its day in this place. On Monday night a Volunteer Fire Department was organized and already it has 45 members. The offices elected were: President, Robert Leslie, Vice-President, William Reeve, Treasurer Philip Detrick, Secretary, Harry C. Burns, Chief, William Decker, First Assistant Chief, John J. Barrett, Second Assistant Chief, Irving Sparrow, Foremen, Harry W. Hughes and Thomas Sherry, Sergeant at Arms, George E. Versoy, Steward, Charles I. Beck." (Courtesy Anthony Vecchio.)

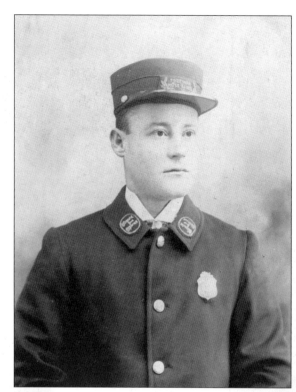

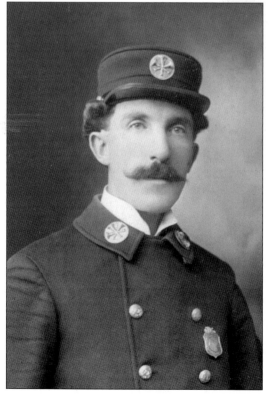

A member of the fire department from 1901 through 1910, Charles Searles Sr. began as an assistant driver and was paid $40 per month. During his tenure, Searles rose to the position of assistant chief. Traditionally, firemen worked nine days straight, had one day off, and returned to work for another ten-day stretch. When working, the men were on duty 21 hours each day. Substitute coverage was provided during the three hours that firemen took off to eat. After one year, they received two paid vacation days. In 1900, the average fireman was paid $56 per month. (Courtesy Anthony Vecchio.)

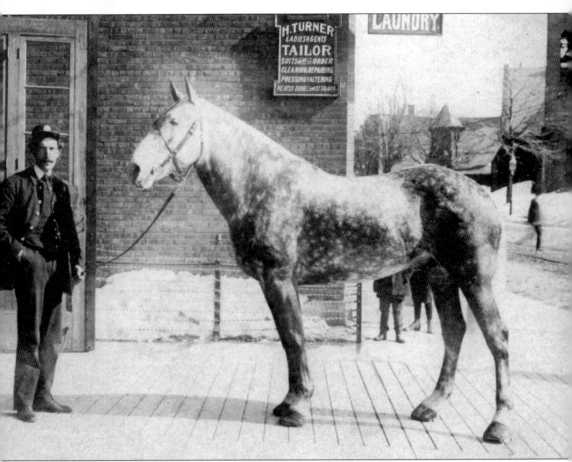

Charles Searles Sr. is shown holding Kernan Horse in this *c.* 1916 photograph, taken outside the second firehouse, on South Orange Avenue and Scotland Road. Horses were integral to the successful operation of the fire department and were well cared for. Early records kept by the fire chief indicate that monthly purchases from H.J. Pierson & Son (a local feed store) included hundreds of pounds of bran, bags of oats, bales of hay, Manhattan Jud Jun (horse liniment), hoof oil, brushes, blankets, lamp oil, and weekly repairs on leather harnesses. (Courtesy Anthony Vecchio.)

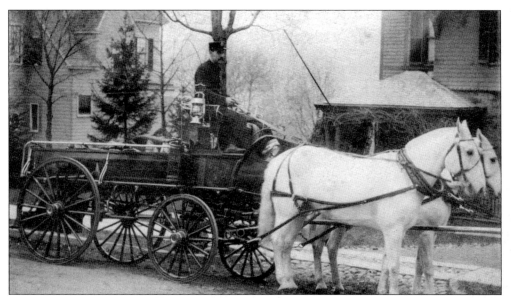

Patrick McCahery poses on Scotland Road. The team of white horses pulls the new hose carriage, built in March 1898 by a local carriage maker. The hose carriage travels with hand lights, 1,000 feet of two-and-a-half-inch fire hose, axes, and hydrant tools. Horse-drawn wagons were in continuous use until 1926. (Courtesy Anthony Vecchio.)

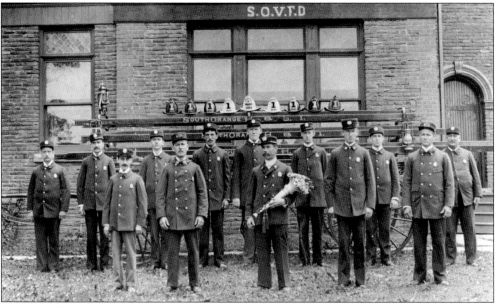

This c. 1895 photograph shows the South Orange Village Fire Department standing in front of the hand-drawn ladder truck. This ladder truck was purchased in 1891 from the Gilbert Barker Manufacturing Company. The purchase price of $300 included all of its fixtures. Shown from left to right are the following: (front row) Harmon Hart, H.J. Becker, Chief William D. Decker, Patrick Skiffington, and John Stieve; (back row) H. Markthaler, J.P. Feindt, C.J. Feindt, Charles Searles Sr., Patrick Reynolds, William A. Ball, V.J. Hill, and P. Deitrich. Chief Decker is holding a sterling silver trumpet, which was used by the foreman to yell out commands at fire sites. (Courtesy Anthony Vecchio.)

Located on South Orange Avenue at the corner of Scotland Road, this *c.* 1900 real estate and telegraph office was centrally located and served local residents. Although telephone service began in neighboring towns as early as 1879, by 1884 there were only 18 subscribers. By the beginning of the 20th century, major communications were still made via telegraph. John S. Magee (seated, front left) was a telegraph operator who learned his craft while working for the community. By about 1910, demands for local telegraph operators had dwindled and Magee (still a local resident) was employed as a telegraph operator for the Delaware, Lackawanna & Western Railroad. (Courtesy South Orange Public Library.)

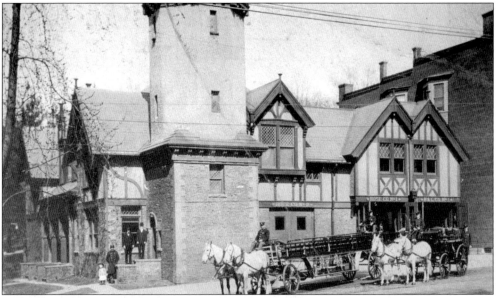

Two teams of white horses pull the hose ladders onto South Orange Avenue. Reviewing the teams are, from left to right, three-year-old Florence Searles; her father, Charles Searles Sr.; James Allen; Charles Barrett; drivers George Vanderhoff and Edward Price; and hose cart drivers William Kane and Thomas Foran. Lettering over the doorways identifies the garages as Hose Company No. 1 (left) and Hose Company No. 2. The former was established on February 2, 1991, the day that the fire department was formed. In a short period, it became evident that there was need for a larger department and, on September 22, 1992, Hose Company No. 2 was organized. (Courtesy Anthony Vecchio.)

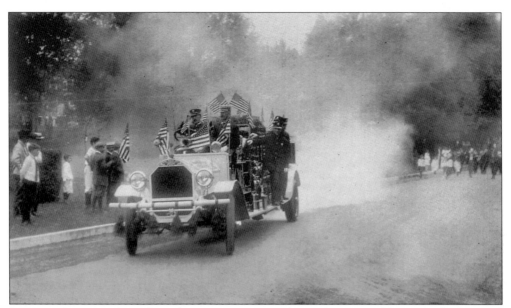

For several years in the early 20th century, Grove Park was the scene of fireworks displays, and fire engines were always on hand in case of accidents. In this photograph, the 1913 Seagrave ladder truck responds to an incident in Grove Park. Traditionally, residents and friends gathered on the grass. Children ran around with sparklers, waiting until dark for the fireworks to begin. (Courtesy South Orange Public Library.)

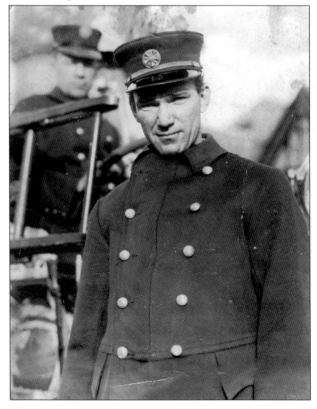

As of June 1, 1913, William Ash of the South Orange Village Fire Department was the first full-time appointment and first paid fire chief in Essex County, New Jersey. He was paid $1,080 per year. First-year firefighters earned $720 a year, and firefighters with five years or more of service made $1,020. Of the 45 members in the fire department, just six were paid members. (Courtesy Anthony Vecchio.)

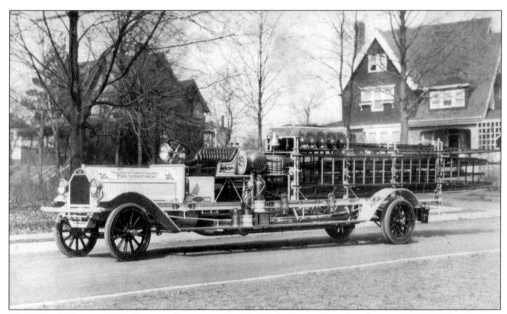

This 1913 Seagrave ladder truck was one of the first motorized units in the South Orange Village Fire Department and was equipped with the first aerial ladder on the east coast. This state-of-the-art fire truck was outfitted with chemical fire equipment, leather fire buckets, a Dietz fire lantern, five leather high-eagle fire helmets, and the original silver fire bell, which is still in use by the fire department today. (Courtesy South Orange Public Library.)

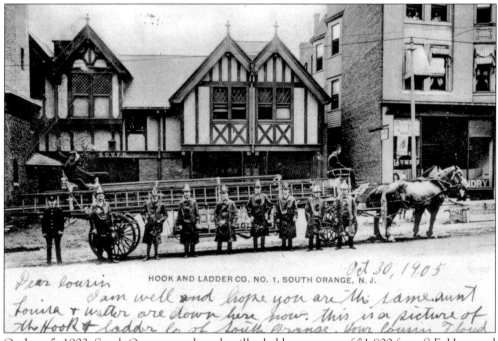

On June 5, 1902, South Orange purchased a tiller ladder at a cost of $1,800 from S.F. Haywood & Company, at 357 Canal Street in New York City. Tillerman Phillip Dietrich is seated on the back of the horse-drawn unit and is responsible for steering the equipment. Charles Searles is seated in the front of the unit. (Courtesy Anthony Vecchio.)

ASSORTED CANAPES

Made on assorted Hors D'Oeuvre crackers prettily garnished and arranged on your platter, ready to serve.

These are $1.50 per dozen with the following fillings used:

Black Caviar
Lobster Paste
Red Caviar
Anchovy Paste
Olive Butter
Roquefort Spread
Sardellen Butter
Egg and Anchovy
Pate de Foi Gras
Etc., Etc.

TEA SANDWICHES
For Your Next Bridge Tea

Shaped in Diamonds, Hearts, Clubs, Spades, Rolled Neapolitan, etc., with following fillings:

Minced Ham
Olive Butter
Devilled Eggs
Minced Tongue
Egg and Anchovy
Egg and Olive
Water Cress
Peanut Butter and Bacon
Peanut Butter and Jelly
Cream Cheese and Pineapple
Mint Sauce
Cream Cheese and Ginger Conserve
Cream Cheese and Stuffed Olives
 and many others.

75c per doz. $5.00 per hundred

A local landmark, Town Hall Delicatessen, at 111 South Orange Avenue, has been serving delicious platters, appetizers, sandwiches, salads, and desserts to hungry customers since the 1930s. Famous for its sloppy joe sandwich (a made-to-order layered sandwich of meats, cheese, lettuce, and Russian dressing on special thin bread), Town Hall Delicatessen honors requests from all over the country and frequently ships sandwiches overnight to sloppy joe fans. (Courtesy Ron Joost.)

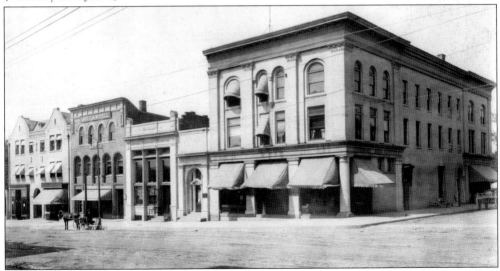

South Orange Avenue in the early 20th century included many businesses, such as the Village Market, Joquam Hall, and People's Bank Savings Investment Trust. By the 1950s, the building with awnings was the site of Ramosa's Bakery, famous for its seven-layer cake. (Courtesy collections of New Jersey Historical Society.)

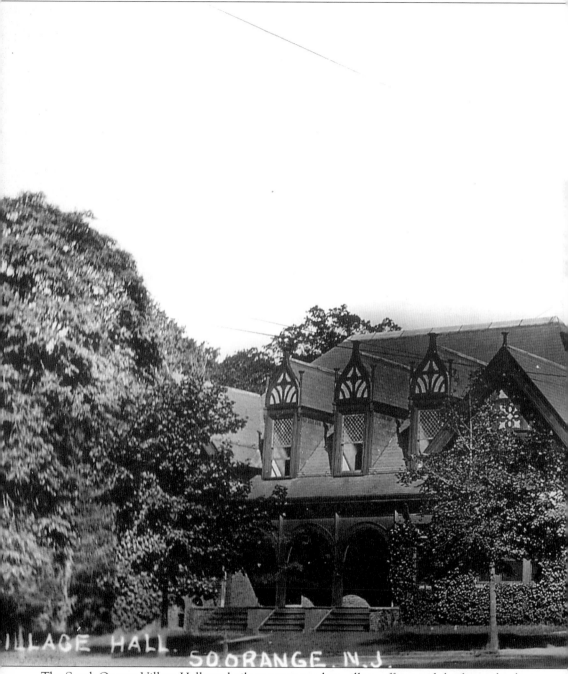

ILLAGE HALL. SO. ORANGE. N.J.

The South Orange Village Hall was built to accommodate village offices and the fire and police departments. Architects Rossiter & Wright of New York City designed this unique building, which became a recognized landmark of South Orange. The half-timber construction suggests the style of work completed in England and Germany during the Elizabethan period. It has been said that the concept of the first Nancy Drew mystery, *The Secret of the Old Clock* (1930), was inspired by the South Orange Village Hall clock. Edward Stratemeyer, who lived in neighboring Maplewood, founded the Stratemeyer Syndicate in the early 1900s and produced

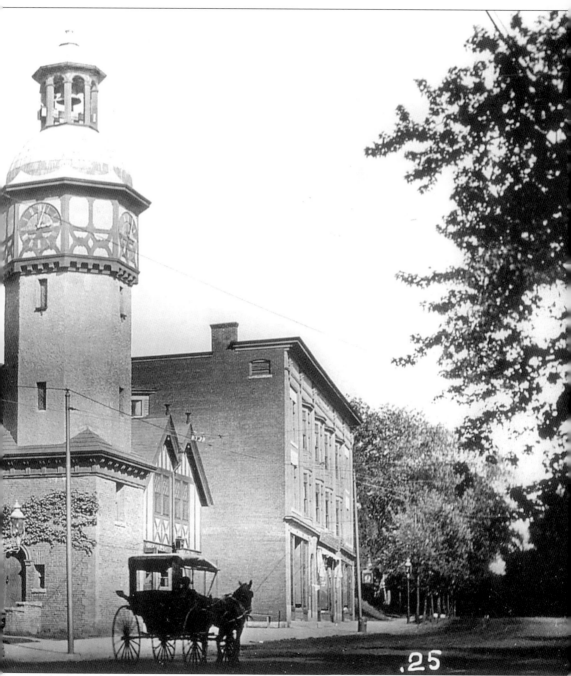

.25

more than 1,200 books, including *Tom Swift*, *The Bobbsey Twins*, *Nancy Drew*, and *The Hardy Boys*. With the success of the first series, *The Hardy Boys*, Stratemeyer sent plot outlines of a new girls' mystery series in 1929 to a ghostwriter who completed the books. In 1930, Simon & Schuster published the first Nancy Drew mystery. It was written under the pen name of Carolyn Keene. The same year that *The Secret of the Old Clock* was published, Edward Stratemeyer died. (Courtesy South Orange Public Library.)

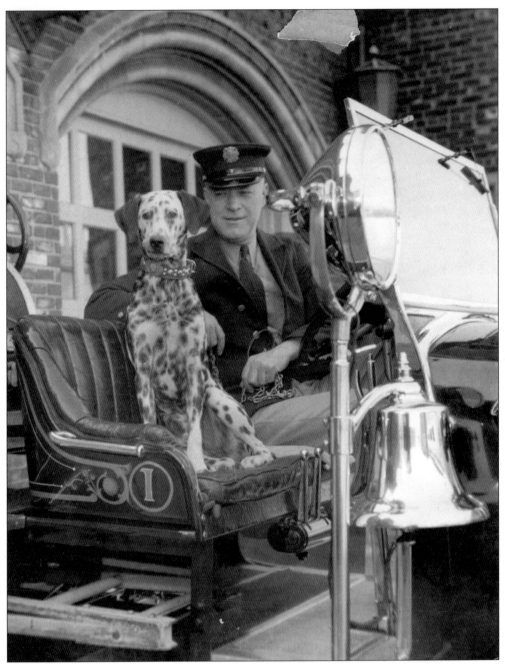

Animals have played an important role in the South Orange Village Fire Department since its inception. Dalmatians were originally used to run between the horses to keep them moving as a team and from nipping at one another. After 1926, when horses were retired from service, Dalmatians became mascots. This 1935 photograph shows firefighter John Boyle with Tony, perched on a state-of-the-art Seagrave fire truck. (Courtesy Anthony Vecchio.)

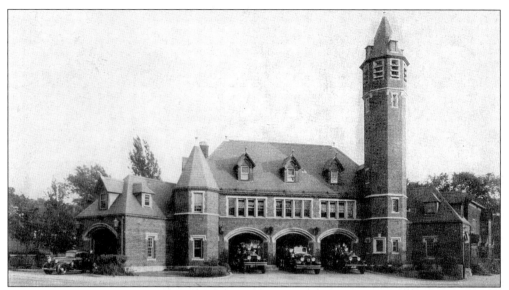

The new fire department building included a training tower designed with vented louvers in place of windows to dry the hoses. Today, 12 lengths of hoses can be dried in the hose tower at one time. By 1969, the South Orange Village Fire Department had three La France 750-gallon pumpers, a Seagrave 65-foot aerial ladder, an 85-foot Seagrave aerial ladder with diesel power, an American La France 1,000-gallon pumper with diesel power, a combination police and fire department emergency van, and a 1964 fire chief's car. In 1969, the department was awaiting delivery of a brand-new 1,000-gallon American La France pumper with automatic transmission that Chief Allen termed "the most modern equipment available today." (Courtesy South Orange Public Library.)

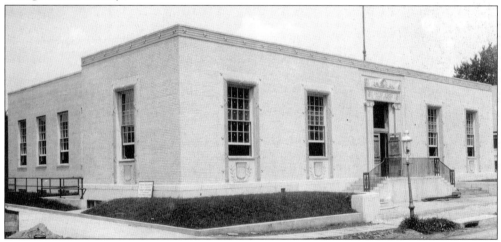

This photograph of the new post office was taken on July 1, 1937. In 1939, the U.S. Department of the Treasury held a competition to commission painted murals for decoration inside post offices. First prize was for the Bronx post office. Second prize was for the South Orange post office. Bernard Perlin (then 21 years old) won a $2,000 commission to paint the mural. Perlin spent nine months on his painting, which depicts recreational pursuits popular in South Orange at the time. It shows a woman reading to two children under a tree, two men gardening, horses, a football player, and a tennis net being installed. (Courtesy South Orange Post Office.)

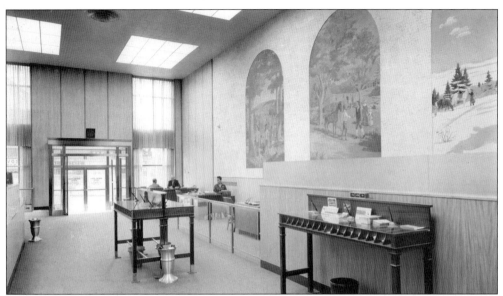

Commissioned in 1951 by the president of the South Orange Trust Company, six murals were painted on the walls of the bank by Stanley Rowland. The project took two years to complete and includes scenes from the village's past. One features a trolley car. Another shows George Washington on top of First Mountain on January 3, 1777, studying the movements of the British on Staten Island and along the Raritan River. Yet another features an idyllic sports scene with the village hall as a backdrop. Today, this is the site of the First Union Bank, and the murals are still an attraction. (Courtesy collections of New Jersey Historical Society.)

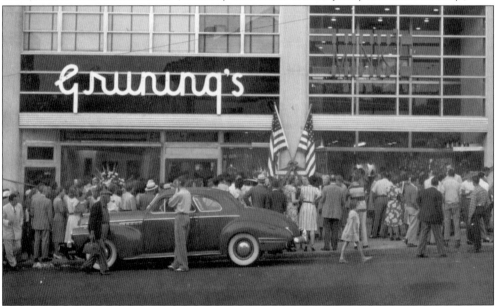

This September 7, 1947 photograph shows a crowd waiting to get inside Gruning's, a landmark ice-cream emporium in the 1930s, 1940s, and 1950s, located at 59 South Orange Avenue. Gruning's served 15 flavors of ice-cream sodas, malts, and sundaes, as well as candy and sodas. It was a major meeting place for teens to gather after any social event or an afternoon at the movies. A nickel would buy a Coca-Cola or a hot chocolate. (Courtesy Marilyn Schnaars.)

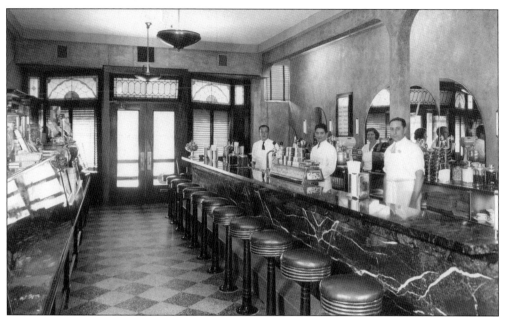

Gruning's c. 1930 interior reveals leaded-glass windows, a sparkling counter with swivel stools, and jukeboxes ready to take coins, play music, and set the stage for dancing. Gruning's came to South Orange in 1929 and eventually had two locations: one downtown and one in the Newstead neighborhood. The first New York City store led to a six-store expansion in several New Jersey towns. A fire in 1946 devastated Gruning's customers but not the business; Gruning's was rebuilt and continued to be a hot spot in town. (Courtesy Marilyn Schnaars.)

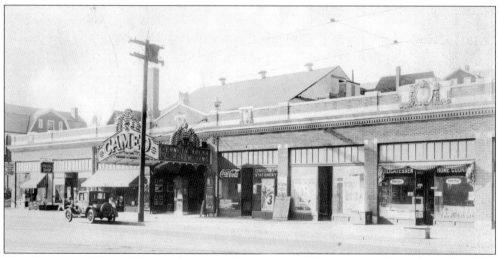

The Cameo, on South Orange Avenue, was a premier destination on Saturday afternoons. Teens spent afternoons in the matinee and were permitted to stay all day if they wished (especially if they were in the back row). In 1930, the price for children under 12 was 15¢. Those over 12 paid 30¢. In 1940, Spencer Tracey visited the Cameo to promote his new black-and-white film, *Edison the Man*. Tracey starred as Thomas Edison. During World War II, the theater featured tin-can day once a month, when any child who brought in tin was allowed to enter the theater for free. (Courtesy collections of New Jersey Historical Society.)

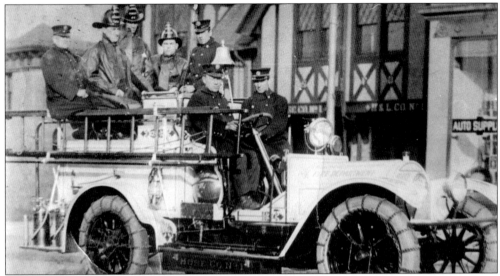

This April 14, 1924 photograph of a Stutz pumper with chains linked to the tires is a modern marvel. It was built by Elder Apparatus in Asbury Park, New Jersey, and has four-wheel drive and a 750-gallon-per-minute pumper hose. The lettering on both sides of the truck is in gold leaf. Chief William Ash is seated on the right side of the fire truck. When the Newstead neighborhood was developed, a fire truck was stored in a garage because there was concern that a truck would not be able to make it up the hill in a snowstorm. (Courtesy Anthony Vecchio.)

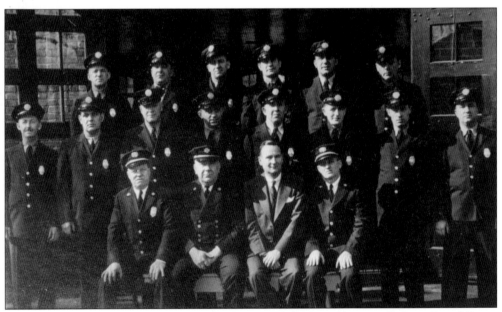

Posing for this group shot are, from left to right, the following: (front row) Capt. David Penn, Chief John J. Loughran, Fire Commissioner John J. Magovern, and Capt. John J. Reynolds; (middle row) Fred Parry, George Bashford, John Boyle, John D. Magee, Charles Searles Jr., Eugene Tracey, John Foley, and Edward Larkin; (back row) William Kenny, Joseph Masi, William McLaughlin, Guy Mercadante, Patsy Ippolito, and William McDonald. (Courtesy Anthony Vecchio.)

Four
PARKS AND RECREATION

South Orange has long been known for its recreational and sporting facilities. From the late 1830s through the early 1890s, the Mountain House Spa attracted visitors who enjoyed a variety of healthy outdoor activities. Those early years established the foundation for village residents to demand parks and extensive recreation facilities.

Both individual and team sports were popular in the 1800s. In 1889, a number of residents formed the Meadow Land Society. The group purchased 23 acres from E.H. Mead that could be devoted to field sports. The society leased the South Orange Field Club for its use and issued $5,000 in stock, which enabled them to maintain the grounds.

In late October 1880, just six years after the game of lawn tennis was introduced to the United States, 30 young men from the Oranges formed the Orange Lawn Tennis Club. Over the years, the Orange Lawn Tennis Club continued to flourish. In the 20th century, the village became well known as a destination for premier tennis tournaments. Orange Lawn was so famous that Alfred Hitchcock's 1951 psychological thriller *Strangers on a Train* features tennis ace Guy Haines (played by Farley Granger), who was recognized as having made the semifinals at South Orange the previous season.

On December 20, 1911, Rev. Lewis Cameron of the Episcopal church deeded land soon known as Cameron Field to the village for a free public playground. It was dedicated on May 30, 1914. In 1969, the village proposed building a subscription pool complex in Cameron Field. Town residents decided to fight the proposal, citing that Cameron's initial deed stipulated that use of the land remain free to the public. The citizens took their fight all the way to the New Jersey Supreme Court and won. In 1972, architectural plans for the new $400,000 Olympic-sized pool, intermediate pool, and wading pool were approved. Today, all South Orange residents swim for a nominal annual of fee of $15 per person.

In the 20th century, parks and athletic facilities were a great source of enjoyment, a trend that continues today. South Orange residents enjoy a wide range of recreational activities in the nearly 79 acres that have been set side for use by its residents.

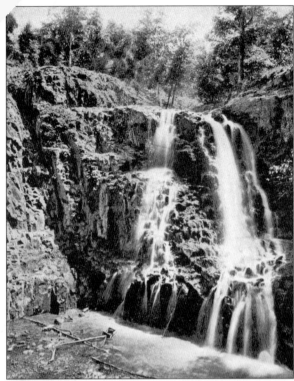

The village of South Orange borders the South Mountain Reservation, a 2,500-acre forest preserve of hiking trails, deer and other wildlife, and Hemlock Falls, one of the premier attractions. Residents could easily walk or ride to the reservation. In the early 20th century, several postcards bearing a photograph of Hemlock Falls were mailed. This card was sent in August 1906. Today, the South Mountain Reservation is part of the Essex County parks system. (Courtesy Amy Dahn.)

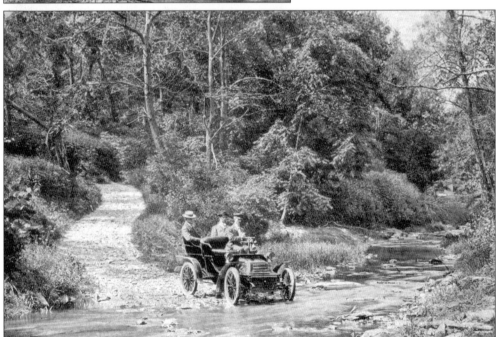

This c. 1904 postcard shows an early automobile fording a stream at the South Mountain Reservation. The sender of this card writes, "This is the ride we didn't take, but I thought you would like to see how you would have looked." (Courtesy Seton Hall University Special Collections and Archives Center.)

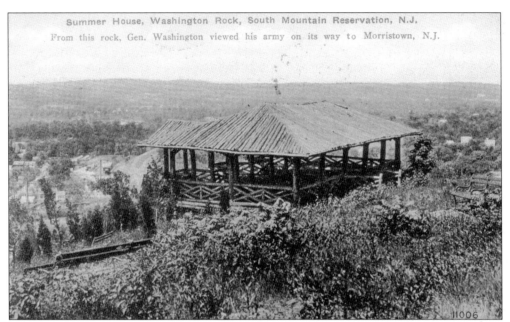

Summer House, Washington Rock, South Mountain Reservation, N.J.

From this rock, Gen. Washington viewed his army on its way to Morristown, N.J.

The summer pavilion at Washington Rock in the South Mountain Reservation is featured on this 1906 postcard. From this spot, Gen. George Washington viewed his troops marching to Morristown. (Courtesy Seton Hall University Special Collections and Archives Center.)

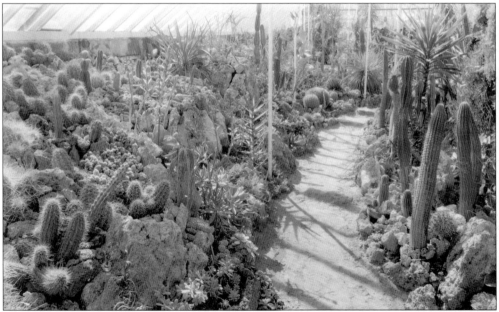

In 1882, horticulturist W. Albert Manda came to America from Europe to collect native plants to be shipped abroad. Before he had completed his project, he was appointed curator at the Harvard Botanical Gardens. In 1898, Manda established greenhouses in South Orange to develop succulents and cacti. By 1933, when Manda died, some 1,200 species of cactus were in his greenhouse, and the South Orange Garden Club had honored him with a statue in Meadowland Park. This photograph shows the interior of one of his greenhouses. (Courtesy collections of New Jersey Historical Society.)

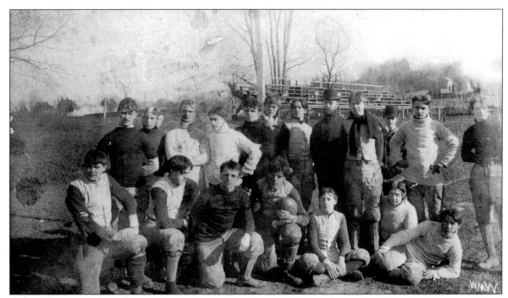

In the 1890s, several boys were interested in athletics, but a school athletic team of any kind was unprecedented. In 1894, a group of 15 boys formed the Prospect Club. Soon thereafter, members of the club joined the South Orange Field Club. In the early 1900s, the opportunity to participate in sports was doubled when the school incorporated athletics into its curriculum. Members of the 1896 South Orange Field Club are shown here taking a break from their football game. (Courtesy Eleanor Farrell.)

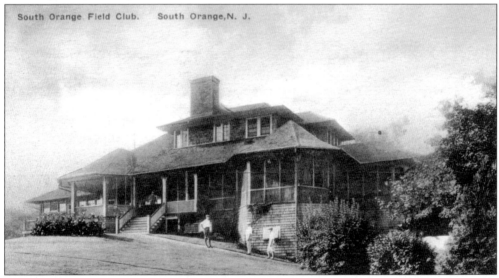

Organized in 1889, the clubhouse used by the South Orange Field Club (a members-only organization) was Edwin Mead's Barn. It burned down in January 1895, and a new clubhouse was immediately built. By 1929, more sports activities were available and the private club became a community center. Fourteen rooms were added in 1930, and it was renamed the Baird Center. In addition to serving the welfare needs of the community, the Baird Center became the central recreation location for the village. The space included 14 clubrooms for approximately 20 groups, a veteran's recreation room, pool tables, four bowling alleys, a craft shop, and three kitchens. (Courtesy Nancy Janow.)

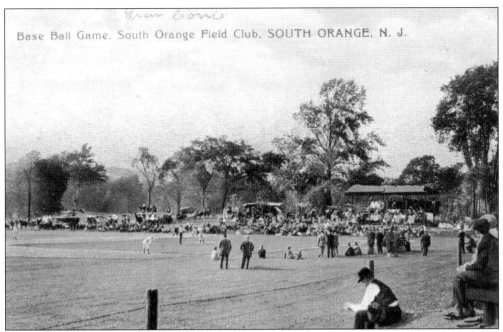

Base Ball Game. South Orange Field Club. SOUTH ORANGE, N. J.

From 1900 to 1935, baseball was a main attraction in South Orange. Crowds gathered at the South Orange Field Club to watch the home team play semiprofessional teams and numerous touring African-American teams, including the Black Yankees, Pittsburgh Crawfords, Cuban Stars, and the Washington Pilots. In 1927, players from the New York Giants played at South Orange, including Frank Lefty O'Doud, Mel Ott, and Charles A. Stoneham II. (Courtesy Seton Hall University Special Collections and Archives Center.)

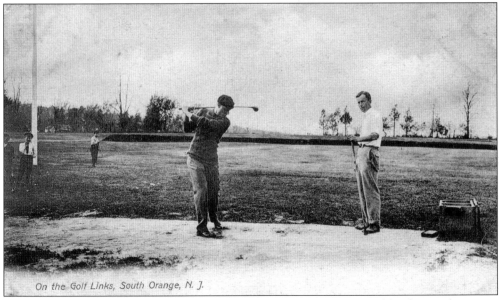

On the Golf Links, South Orange, N. J.

From 1900 until the mid-1920s, Cameron Field was a private club owned by the South Orange Field Club. This postcard shows a player teeing off at the nine-hole golf club named the Lone Oak Links. The ninth hole was positioned where the baseball diamond is now located. (Courtesy Seton Hall University Special Collections and Archives Center.)

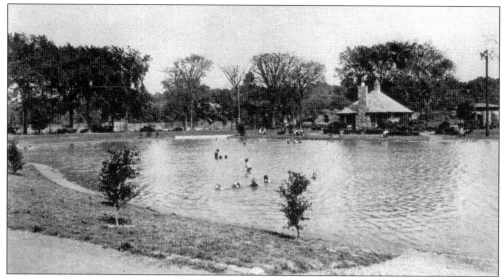

Man-made Meadowland Park Lake, with its small sandy shore and shallow depth, was the premier location in town for children to cool off on sweltering summer afternoons. This 1922 photograph shows swimmers making the most of the lake. Originally, swans swam in the pond, but today, it is called the Duck Pond, so named for the only swimmers willing to test the waters. The Duck Pond also features horseshoe and bocce courts. In winter, ice-skaters take their turn on the pond. (Courtesy Seton Hall University Special Collections and Archives Center.)

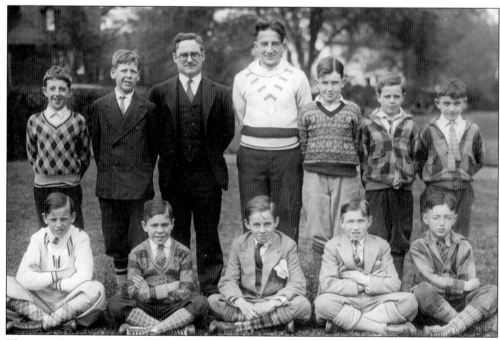

These 11 boys of the 1927 South Orange marbles championship team are shown wearing knickers and argyle socks. The team is joined by its coach and director of the community house, Chauncey Owens (in the dark suit and glasses). Standing to the right of Owens is Tony Zuzuro, manager of operations. (Courtesy collections of New Jersey Historical Society.)

52

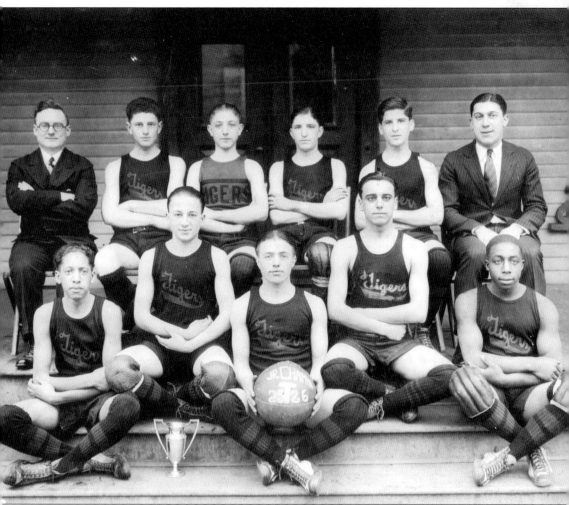

The 1925–1926 Tigers basketball team poses with their junior championship trophy (note the small silver trophy in front). On the top left is Chauncey Owens, director of the community house. On the top right is Paul Ippolito. (Courtesy Joe and Rose Zuzuro.)

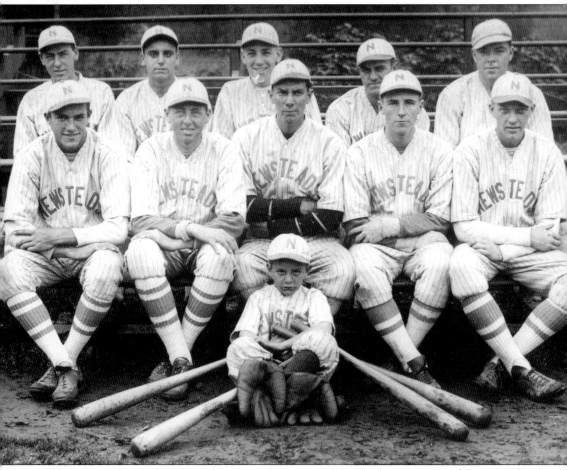

The semiprofessional Newstead team is shown in 1926. The boy sitting in front is Richard "Buddy" Farrell, who later became the director of recreation and cultural affairs for South Orange. The others are, from left to right, as follows: (front row) Howard Conroy, Joseph Canter, John Holander, Louis Kerugue, and Robert Kernan; (back row) Eugene Murphy, George Halander, Bill Rhatigan, Anthony Copetta, and John O'Neill. Team uniforms and baseball equipment were provided by the local store, Stoneham's Hardware. The Stoneham family was related to Horace Stoneham, who owned the New York Giants baseball team throughout the 1930s, 1940s, and 1950s. (Courtesy Eleanor Farrell.)

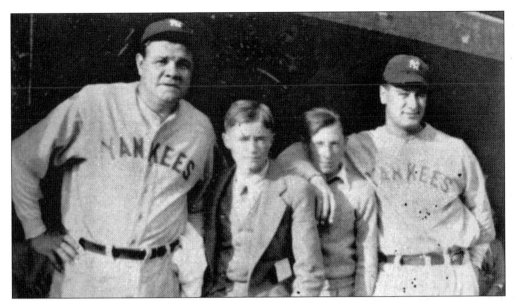

The South Orange baseball team hosted New Brunswick in an exhibition game at Cameron Field on October 29, 1929. Babe Ruth (far left) and Lou Gehrig (far right) played for South Orange in the game. The 12,000-seat grandstand was packed with spectators that included 25 Major League ball players. South Orange defeated New Brunswick 7-6. In this photograph, Owen Larry Keefe, a former *News Record* employee, stands next to Babe Ruth. The other boy is unidentified. (Courtesy News Record.)

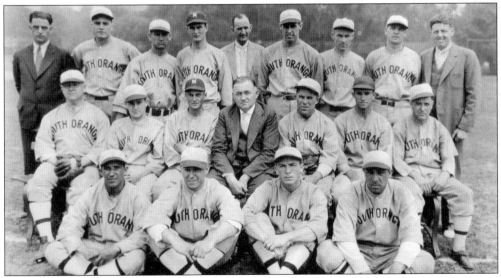

As they faced the New Brunswick team in the exhibition game, Babe Ruth and Lou Gehrig contributed to this South Orange baseball team's championship bid. Shown from left to right are the following: (front row) Ed Ralston, Harry McEnroe, Wuzzy Fullerton, and Fred Schetelich; (middle row) Mike Gazella, Mike Bowe, manager Joe Carter, Joseph A. Carter (in suit), Abbie Leitch, John McEntee, and Steve Plesnick; (back row) Joseph Farrell and eight unidentified. (Courtesy Eleanor Farrell.)

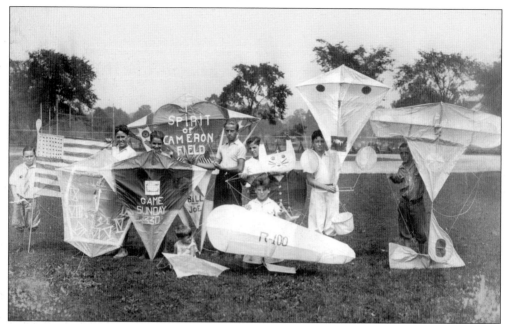

Children show the kites they made for the 1930 kite-making competition in Cameron Field. Every child was eligible to enter; even the child sitting on the ground was a contestant. (Courtesy Eleanor Farrell.)

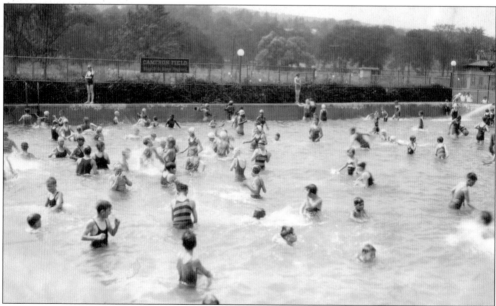

Thanks to Rev. Lewis Cameron, who had deeded property to the village for a free public playground, the South Orange municipal pool (shown here in 1930) was the first free municipal pool in the country. The pool was built in the mid-1920s to serve local swimmers. In this 1930 photograph, boys and girls alike can be seen wearing full-length, one-piece swimsuits that were popular attire for swimming in 1928. In the 1940s, rules were changed and boys only swam from 9 a.m to 11 a.m., and girls swam from 11 a.m. to 1 p.m. Adults could swim any time. (Courtesy Eleanor Farrell.)

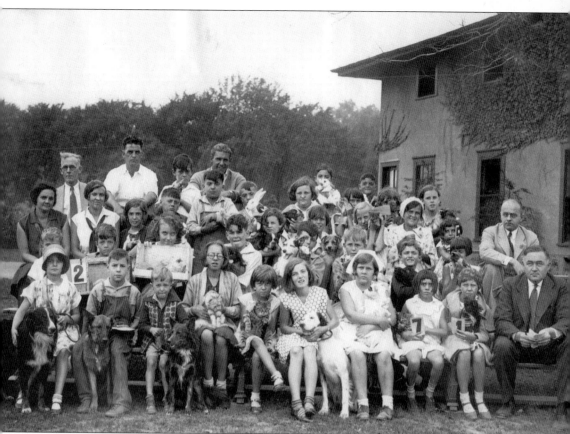

The playground near the Farrell home in Meadowland Park is the site of this mid-August 1930 pet show, which attracted more than 300 entrants. Judges John Waterfield, Alexander W. MacKenzie, and recreation commissioner Joseph A. Carter (seated in the front row) awarded several prizes. The winners posed for this photograph. First prizes went to Dolores Murray in the dog class, Herbert Schenck in the cat class, Carroll Rock in the white rat class, John Mercadante (who also won in the duck class) in the rabbit class, and Jean Sharkey in the chicken class. (Courtesy Eleanor Farrell.)

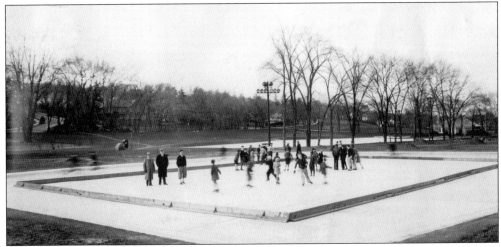

This 1933 photograph shows children enjoying an afternoon at the outdoor skating rink at Cameron Field when they covered over the baby pool. In winter, it was flooded for ice-skating, and in fall and spring it was used for roller-skating. Skating could also be a romantic evening date under the lights. (Courtesy Eleanor Farrell.)

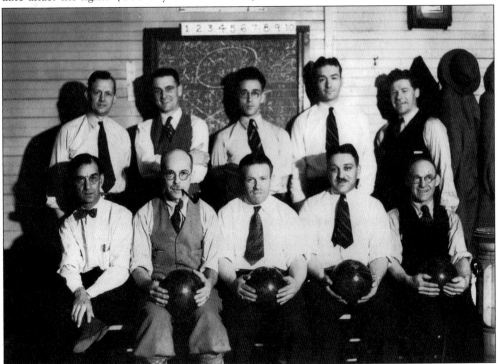

This 1935 photograph shows the Seton Hall Barbers, a bowling team sponsored by barber Mike Williams (front row, fourth from the left). They are wearing what was evidently considered suitable bowling attire: knickers, vests, and short ties. Third from the left in the back row is Ray Nypert. His father is in the front row on the far right. Four bowling lanes were located at the Baird Center and hosted competition between teams such as the Comerfords, Owls, Scotts, Abbott-Hogan, Seton Hall Barbers, Colonials, and the Village Departments. (Courtesy South Orange Public Library.)

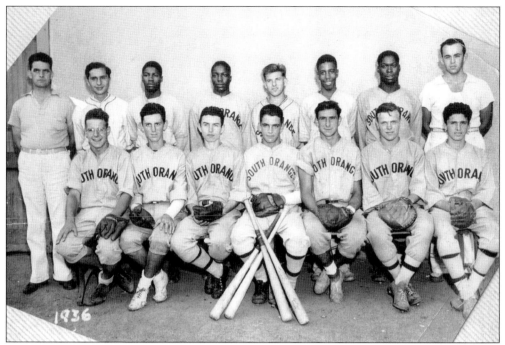

Pictured is the 1936 South Orange baseball team. From left to right are the following: (front row) unidentified, Tom King, Harry Ash, Richard "Buddy" Farrell, Pat Lagavenese, and two unidentified; (back row) Joseph Farrell, George Iantosca, four unidentified, Mike Roman, and Spud Carter. (Courtesy Eleanor Farrell.)

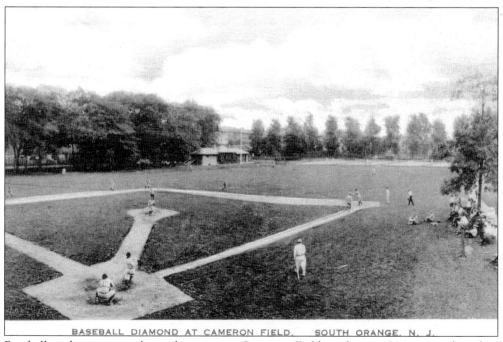

Baseball enthusiasts are shown lounging at Cameron Field in this c. 1914 postcard as they watch an informal game.

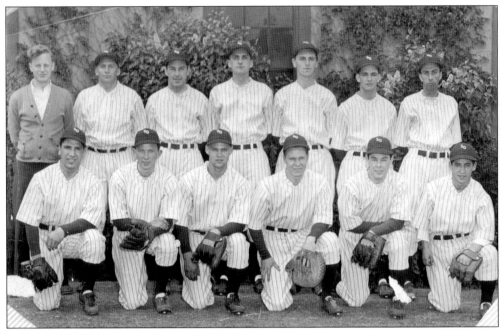

This 1940 team of former high school and college baseball stars played Minor League teams every Sunday at Cameron Field. Shown from left to right are the following: (front row) Ken Sausville, Bob Hagen, Greg Hillman, Syn DeRoner, Joe Murphy, and Ted Corage; (back row) Herb Benson (the business manager), Walt Weismiller (an all-star center for CHS football), George Murphy, Sandy Fox, Tom King, Richard "Buddy" Farrell, and Bob Smith. (Courtesy Eleanor Farrell.)

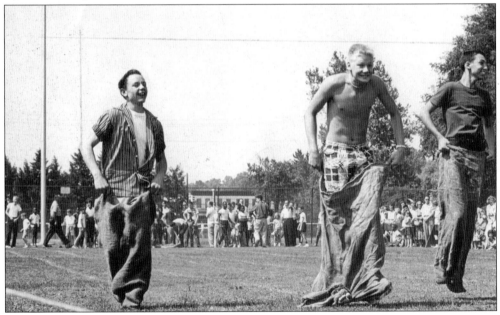

Throughout the 1930s and 1940s, activities were arranged throughout the summer to engage residents in community activities. In this *c.* 1948 photograph, three boys enjoy a sack race in Meadowland Park. (Courtesy Eleanor Farrell.)

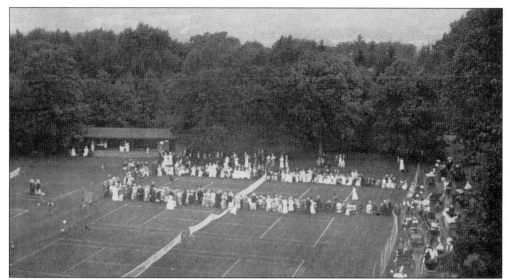

On October 4, 1880, 30 young men formed the Orange Lawn Tennis Club at the intersection of Montrose and Berkeley Avenues on 10 acres. There, eight grass courts and two earth courts were built. In a July 4, 1884 *Harper's Weekly* article, Orange Lawn is described as "located on the crest of the high ground . . . hemmed in on all sides by groves of chestnuts and oaks." The club remained in this location for 36 years until it moved to a larger location on Ridgewood Road in 1916. (Courtesy Orange Lawn Tennis Club.)

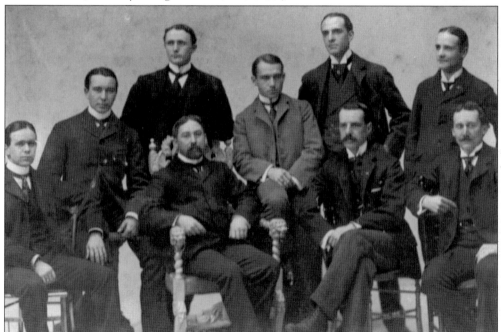

Walter Osborne served as president of the Orange Lawn Tennis Club from 1897 to 1900. This *c.* 1899 photograph shows the dapper key members of the club. From left to right are the following: (front row) Clifford Gould, Walter Osborne, Frank Hagemeyer, and Carmen Runyon; (middle row) Russell Griffin, Edward Lyman, and Tom Kingman; (back row) Edgar Camrick and Robert Miller. (Courtesy Orange Lawn Tennis Club.)

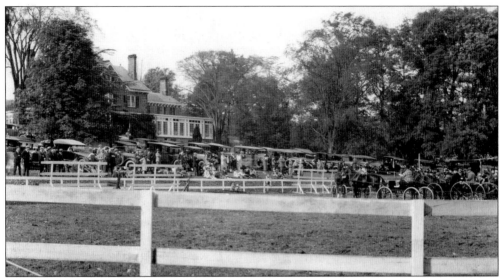

From 1921 through 1939, the annual Orange Lawn Tennis Club horse shows were held on the grounds below the clubhouse, near Ridgewood Avenue. There were as many as 43 classes judged and a maximum of 393 entries. The first years had 21 classes of competition, including jumpers, saddle horses, troopers' mounts, officers' chargers, saddle ponies, road hacks, and hunt team hunters. In 1927, there were 38 classes and, by 1930, there were 40. In 1934, the military team competition included the Montclair Mounted Troop, the Junior Essex Troop, and the West Point Horse Show Team. A gala ball was held on the Saturday evening after the show. (Courtesy Roy Scott.)

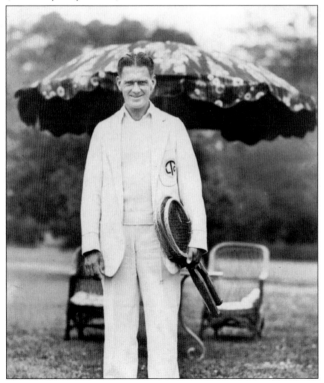

Wearing the distinctive Orange Lawn Tennis Club logo on his jacket pocket and holding two favorite racquets is J. Gilbert Hall, the 1930–1931 club tennis champion. In 1935, Hall was ranked eighth nationally. (Courtesy Orange Lawn Tennis Club.)

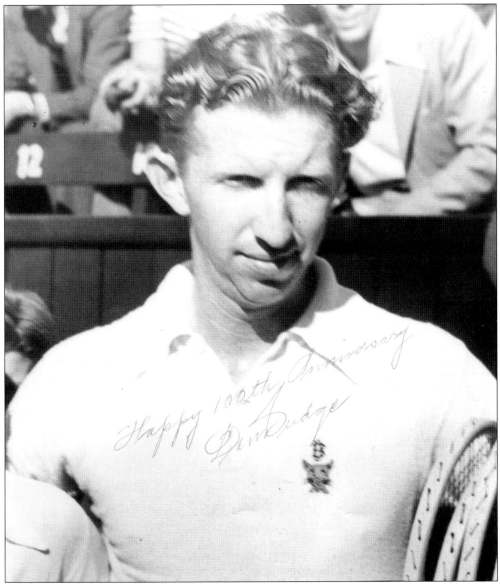

From 1930 through 1935, an annual East vs. West Tournament was staged at Orange Lawn for two days in August. In 1934, 19-year-old Don Budge, playing for the West and on grass for the first time, beat Sidney Wood. Frank Parker (East) defeated Gene Mako. The matches were tied at five each. In 1936, the Eastern Grass Court Championships, held at Orange Lawn, resulted in Don Budge (ranked first in the United States) winning the men's singles championship. (Courtesy Orange Lawn Tennis Club.)

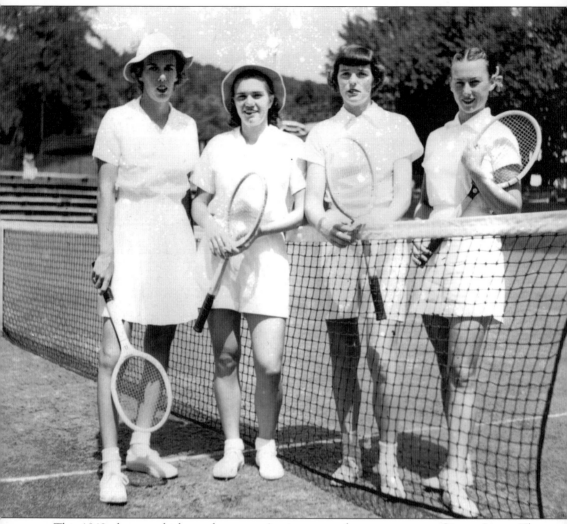

This 1949 photograph shows the women's winners on the grass courts at Orange Lawn. They are, from left to right, Doris Hart, Shirley Fry, Pat Todd, and Gussie Moran. Doris Hart beat Shirley Fry in the women's finals and Gussie Moran (famous for her shocking lacey underpants) and Pat Todd won the doubles. (Courtesy Orange Lawn Tennis Club.)

One of the leading women amateur players from 1950 to 1958, Althea Gibson dominated women's tennis in 1957 and 1958. Gibson was the 1956 and 1958 champion of the Eastern Grass Court Championships, held at the Orange Lawn Tennis Club. Gibson retired from tennis at the height of her tennis career, in 1958, and became a professional golfer. (Courtesy Orange Lawn Tennis Club.)

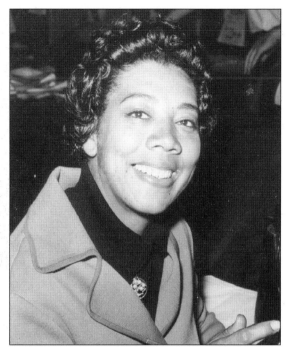

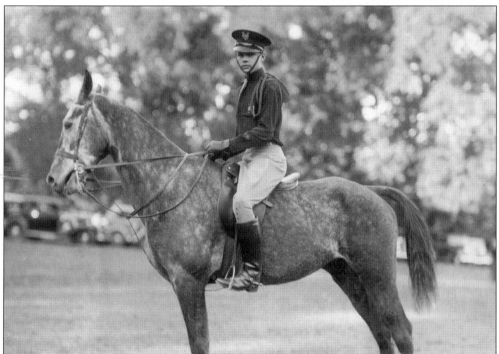

Between 1921 and 1939, the Orange Lawn Tennis Club hosted an annual horse show. In 1934, it incorporated a military team competition that included the Montclair Mounted Troop, the Junior Essex Troop, and the West Point Horse Show Team. This 1937 photograph features Carleton B. Riker Jr., a member of the Montclair Mounted Troop, ready for the competition. The team finished in the top five for the year. (Courtesy Carleton B. Riker.)

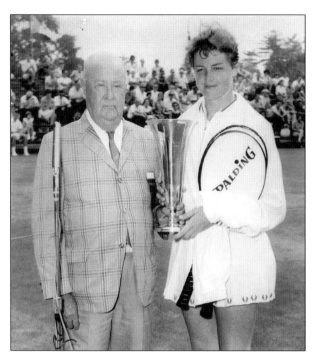

Shown with James Dickey (first vice president of the U.S. Lawn Tennis Association and president of the Orange Lawn Tennis Club) is Margaret Court Smith, the 1962–1963 champion of women's singles Eastern Grass Court Championship. Smith is wearing a Fred Perry tennis outfit. (Courtesy Orange Lawn Tennis Club.)

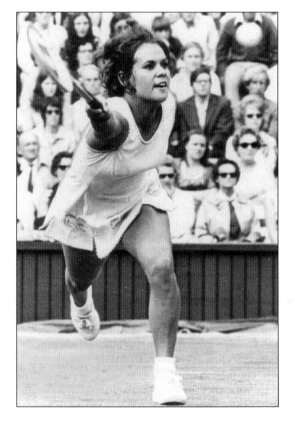

One of Australia's most successful tennis players, Evonne Goolagong entered Wimbledon in 1969. The following year, Goolagong became the first aboriginal Australian to win Wimbledon and, in 1971, began her winning career, during which she won 92 professional tournaments. Here, Goolagong takes to the court at the Orange Lawn Tennis Club. (Courtesy Orange Lawn Tennis Club.)

The Orange Lawn Tennis Club hosted the Eastern Grass Court Championships in 1969. Stan Smith won the Men's Singles Championship that year. (Courtesy Orange Lawn Tennis Club.)

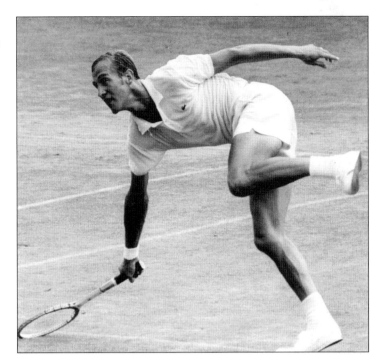

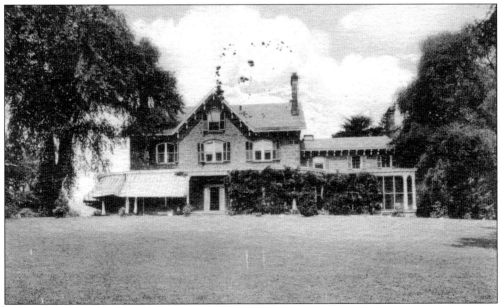

By early 1916, the popularity of tennis and the Orange Lawn Tennis Club strained the facilities at the original Berkeley and Montrose Avenues location. The club membership wanted more courts as well as more fashionable facilities for social evens. A search committee was formed and, as luck would have it, the Redmond estate, known as Hillside, suddenly became available. In November 1916, the property became the new (and current) location of the club. Tennis there is still very popular today. (Courtesy Seton Hall University Special Collections and Archives Center.)

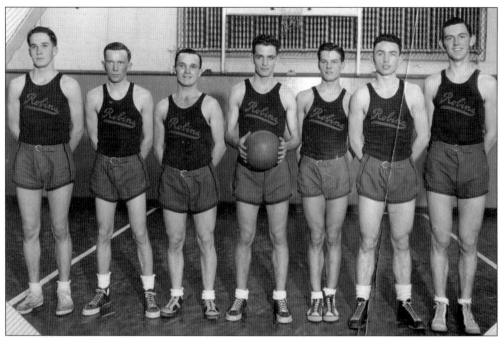

Suited-up members of the 1938–1939 Robins, the junior varsity basketball team at the South Orange Community House, include, from left to right, Don Johnson, Robert Hagen, Francis Manning, Richard "Buddy" Farrell, Paul Schobent, Harry Ash, and Tom King. The 1940 Robins captured the championship by winning 10 straight games over the Lackawannas and the Cardinals. To secure a position in the playoffs, the Cardinals beat the Gems. (Courtesy Eleanor Farrell.)

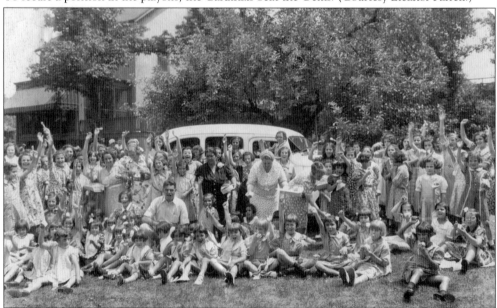

In August 1939, several South Orange groups came together to organize a full day of merry-making for 116 orphans who participated in games, sporting activities, and lots of good food. This photograph, taken in the South Orange Playfield, shows adults and children alike enjoying cupcakes and ice cream. (Courtesy Eleanor Farrell.)

In the 1940s, Santa found time to be a regular visitor to South Orange. In this photograph, he poses with three children in front of a special mailbox, which had been set up in Cameron Field just for letters to Santa. (Courtesy Eleanor Farrell.)

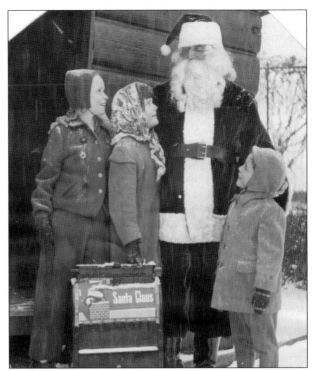

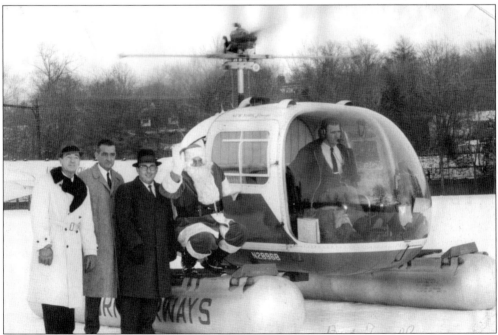

Developed in Spain c. 1929, the autogyro preceded the helicopter by about 10 years. The helicopter was still a novelty in 1947, when Santa amazed children and adults alike by arriving by chopper at Cameron Field to wish everyone in South Orange a merry Christmas. Shown from left to right are Lou Kernan, Bud Farrell, an unidentified local realtor, and Santa (Mose, the dog catcher). (Courtesy Eleanor Farrell.)

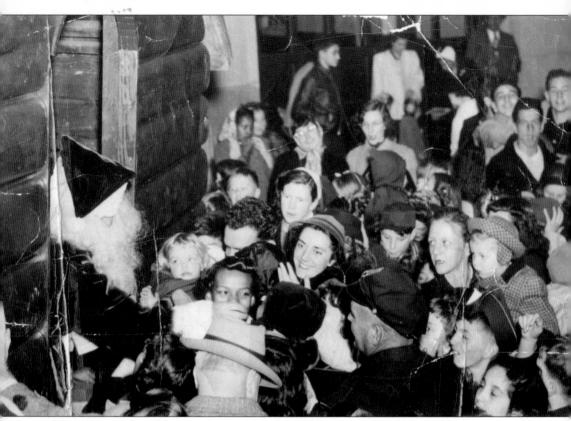

This 1944 photograph shows Santa at his special house, which was set up indoors at Cameron Field, where he could ask each child in town what they wanted for Christmas. (Courtesy Eleanor Farrell.)

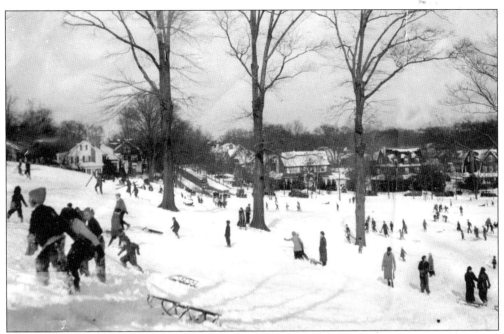

The timeless childhood winter sport of sledding is featured in this c. 1940 photograph of children taking advantage of a big snowfall in South Orange. Although Redmond owned this property in the late 1800s, Flood's Hill was so named because Flood rented this property, upon which he grazed Jersey cows. Today, the village owns the property, but it is still identified as Flood's Hill. (Courtesy Eleanor Farrell.)

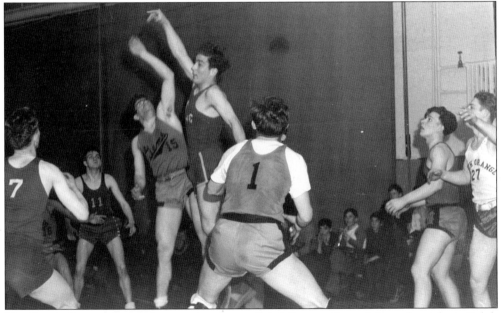

The South Orange Gems play a scrimmage at Baird Center. Second from the right is Ralph Sazio, an all-metropolitan football player in Columbia. He signed with the Brooklyn Dodgers football team and later played for the Montreal Alouettes, a team he subsequently purchased. (Courtesy Joe and Rose Zuzuro.)

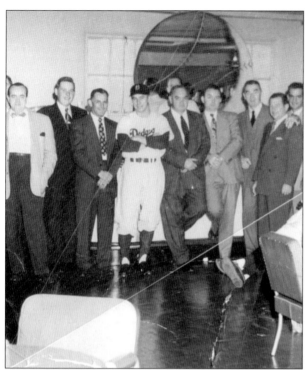

Village officials and sports enthusiasts are shown basking in the glow of Dodger baseball star Pee Wee Reese. The photograph was taken *c.* 1950 at the Masonic Temple, at the corner of Irvington and Prospect Streets. (Courtesy Eleanor Farrell.)

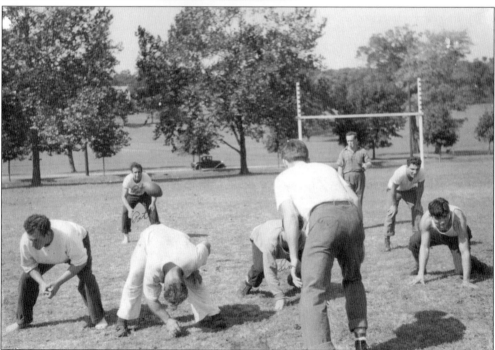

This pick-up football game in the late 1930s shows Pat Lagravenese (rear, left) about to catch the football. Lagravenese's son became a successful Hollywood screenwriter with such credits to his name as *Bridges of Madison County*. In the front left corner of the photograph is Lou Maglioro. In the front right is Gerry Polcaro. (Courtesy Joe and Rose Zuzuro.)

Five

EDUCATION

Since the 19th century, community leaders have banded together to create schools unsurpassed in beauty of setting and architectural design, with desirable equipment and courses of study. It is estimated that the first school was built in the mid-18th century, since documents indicate that it was repaired in 1787. It was located at the corner of Academy Street and South Orange Avenue.

In 1815, a two-story wooden building was built on Academy Street and named the Columbian School. In 1880, the old wooden school was replaced by a two-story brick building. In 1885, a kindergarten class was created. When a three-year high school course was established, the new school was called Columbia High School. The original Columbia High School became the South Orange Junior High School, with additions being made to the building in 1898 and 1900.

Marshall School was built in 1922, the First Street School in 1923, Tuscan and Montrose schools in 1924, South Mountain in 1929, and Newstead in 1955. A new Columbia High School building was opened in 1927 to serve both South Orange and Maplewood students.

Seton Hall College (founded in 1856 by the first bishop of Newark, James Roosevelt Bayley) is the oldest diocesan university in the United States. The university opened its doors to a small group of students in 1856. Despite lean years during the Civil War, major fires, and several setbacks, the college continued to expand. By 1872, enrollment increased to 500 freshmen from 17 states and six foreign countries. By 1937, Seton Hall was established as a university, which marked the first matriculation of women at Seton Hall. In 1968, Seton Hall became fully coeducational.

By 1900, total enrollment in the Columbia School (1898–1910) was 790 students, with 116 students in high school. The school had 27 teachers who earned an average salary of $720. By 1910, total enrollment was 1,216, with 168 students in the high school. There were a total of 43 teachers, and their average salary was $900. (Courtesy Columbia High School.)

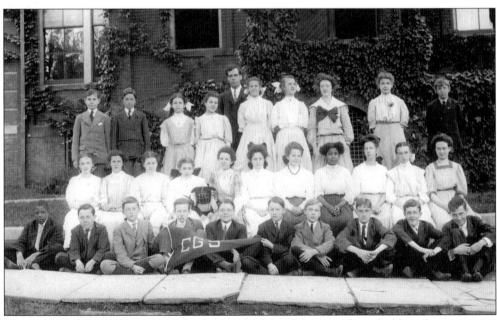

This *c*. 1906 photograph of the Columbia Grade School shows students holding their pennant. Behind the pennant is their class mascot, wearing a muzzle and neckerchief. Judging by the slant of his ears, the mascot must not be very happy. (Courtesy Columbia High School.)

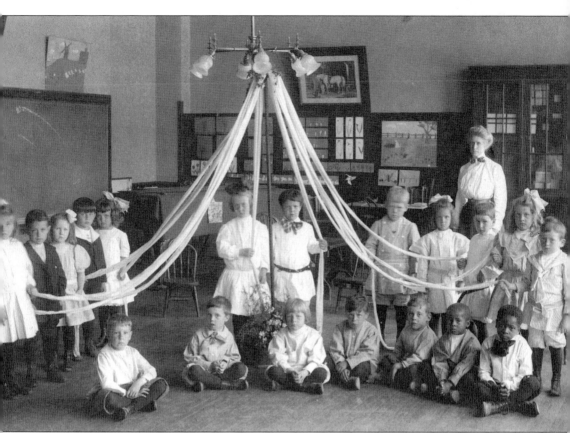

This first-grade class celebrates May Day with a maypole and streamers. Celebrating May Day and the arrival of spring was a common school and community activity in the early 20th century. (Courtesy Columbia High School.)

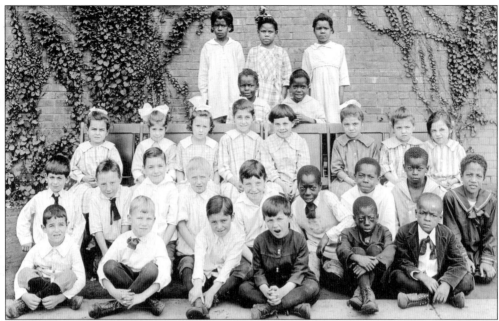

This 1919–1920 photograph shows a diverse group of children posing in front of Columbia School. Despite an increase in enrollment by 80 percent (1,577 students) between 1914 and 1922, no new construction took place, as World War I encouraged a patriotic duty to avoid noncritical expenditures. (Courtesy Columbia High School.)

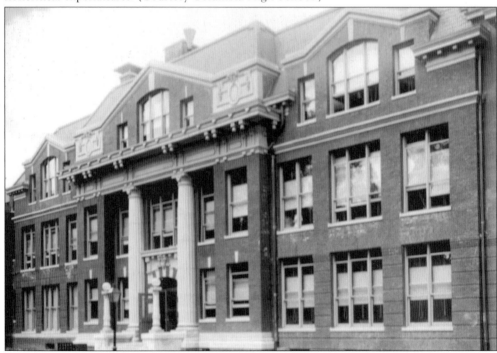

This photograph shows the original South Orange Junior High School, located on Academy Street. As a junior high school, it accommodated grades seven, eight, and nine. It was subsequently torn down.

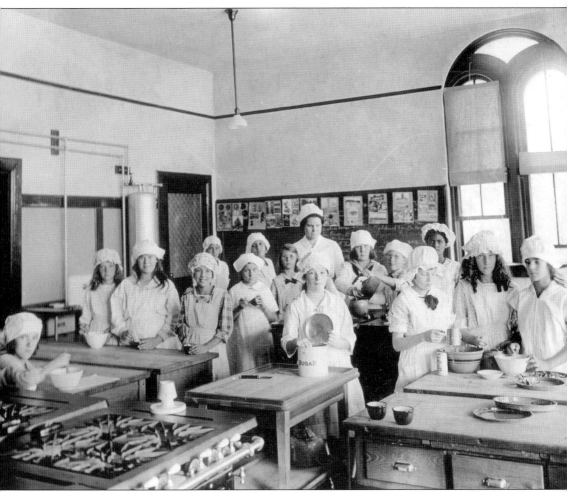

Already learning the basics of becoming superior homemakers, these members of a 1920 class of elementary school girls show off their skills in measuring and mixing. Promoting the benefits of cleanliness in the kitchen, each student is shown wearing an apron and sporting a white cap. (Courtesy Columbia High School.)

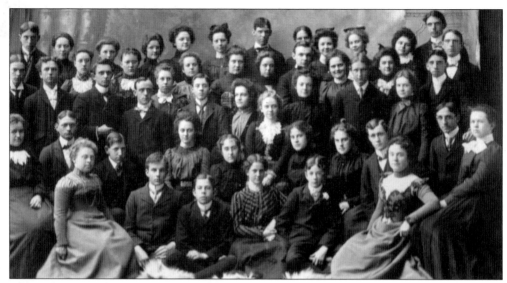

This is the Columbia High School class of 1884. During these students' high school years, the school system continued to evolve. In 1883, the annual compensation for principal J.B. Maxwell was increased to $1,500. Mary D. Squier, teacher of English and vocal music, was engaged at an annual salary of $500, and J. Knox Phillips was empowered to contract for slating blackboards at 4¢ per square foot. Until this time, blackboards were made of wood. Beginning in 1884, teachers were permitted to a one-day absence to visit and observe other teachers' classrooms. Also in 1884, Henry Bendwig began his 34 years of service as a janitor. (Courtesy South Orange Village Hall.)

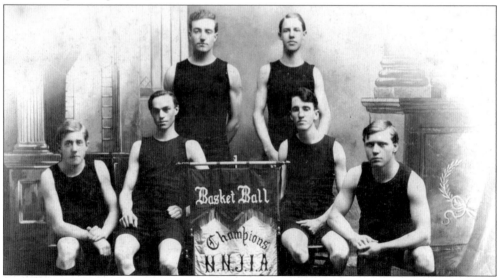

In 1901, Columbia High School joined the Northern New Jersey Inter-Scholastic League and, in 1903, were the league's basketball champions. The league consisted of high schools from five nearby communities and competitive meets rotated among each school. When South Orange hosted the competitive games, they were held at the South Orange Field Club, which charged a small fee. The league dissolved after a few years due to disharmony in enforcing standards of eligibility and conduct and the impossible task of keeping the playing area free from partisan masses of the local team. (Courtesy Columbia High School.)

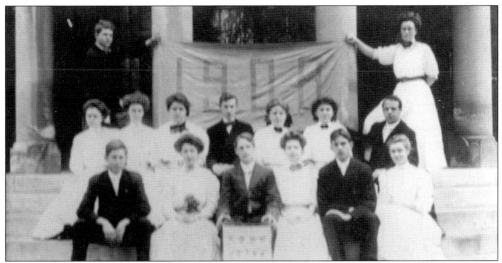

This 1908 Columbia High School class poses on the steps of the Methodist church. Beginning in the 1890s, physical activities were seen as positive for healthy development of children and young adults. In 1913, however, there was concern about the new freedom in dress and of animalistic dances. Corsets and long dresses were being put aside, as they interfered with athletic activities. Animalistic excitement was also a concern, as officials noted that musical rhythm from the wilds of barbarism stirred the pulse. The refined waltz and polka were out, replaced by the favored bunny hug, turkey trot, fox trot, and shimmey. In March 1913, the board of education stated that all social events should include polite dances and exclude the turkey trot and others of similar character. (Courtesy Columbia High School.)

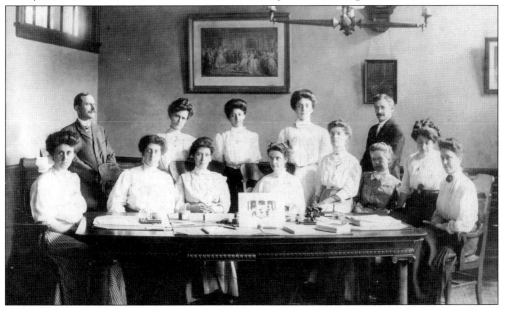

This faculty photograph from 1908–1909 shows the 11 women and two men who were in charge of instruction at Columbia High School. In the early 20th century, the board of trustees felt that women were better suited to teaching than men were, and the hiring trend for new teachers leaned toward women. Today, many faculty members hold advanced degrees and faculties are representative of a diverse population. (Courtesy Columbia High School.)

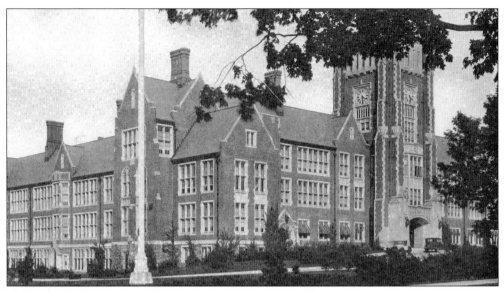

Many changes began to take place beginning in 1867, when students were first divided into different grades. In an 1870 election, tuition became free. In 1880, the old wooden school building was replaced by a two-story brick building. A kindergarten class was created in 1885. When a three-year high school course was established, the new school was called Columbia High School. Between 1887 and 1893, school supplies and textbooks were free. In 1894, control of the schools was taken over by the state. The end wings of this building were added in 1898 and 1900. In the 1929 edition of *Encyclopedia Britannica*, the floor plan for Columbia High School was shown as a superior layout for a public school. (Courtesy Alan Angele.)

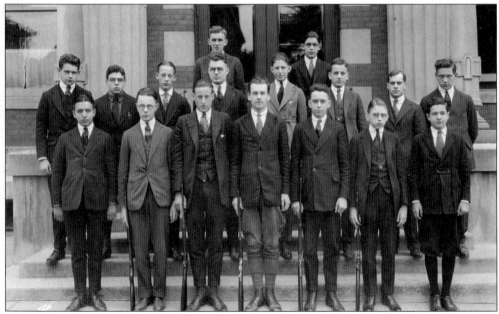

Students at Columbia High School were encouraged to explore a variety of interests. These 16 boys and their faculty leader make up the *c.* 1915 Columbia High School Rifle Club, which focused on the skill of sharpshooting. It is not known whether the board of education furnished the firearms. (Courtesy Columbia High School.)

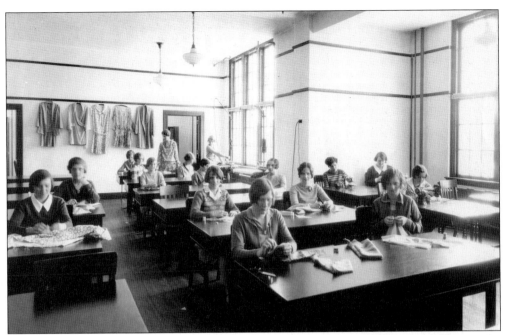

Columbia High School incorporated student training in the domestic chores, including sewing by hand. Five completed dresses hang on the back wall as this class works on clothing projects. One student in the back can be seen pressing a dress. (Courtesy Columbia High School.)

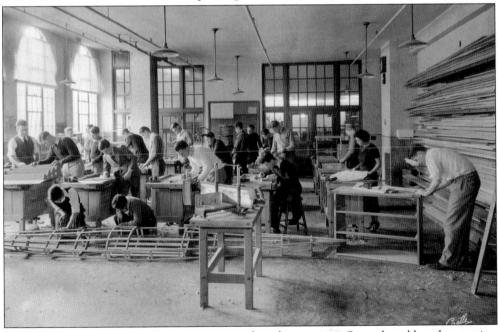

Columbia's woodshop offered extensive materials and equipment. Several workbenches, a miter saw, and a supply of fine wood made it possible for students to build more than a shoeshine box. Students work on a variety of projects, including two students in the foreground who are building a boat. State-of-the-art shop classes are still offered today. (Courtesy Columbia High School.)

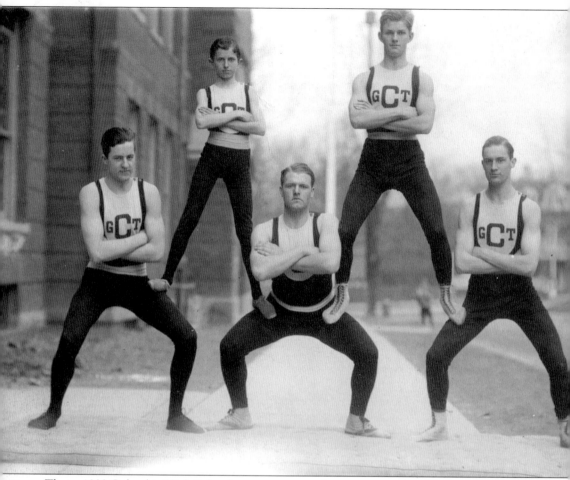

The *c.* 1908 Columbia High School gymnastics team boasts an assortment of athletic men in a variety of sizes. The role of the smallest member, shown on the top left, is to climb to the top of the pyramid. (Courtesy Columbia High School.)

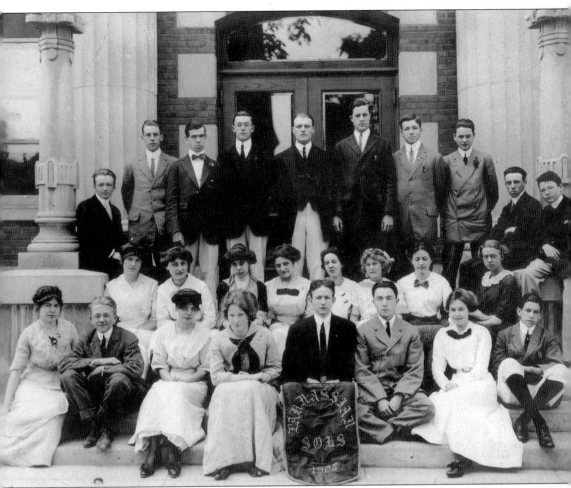

The 1905 Parnassian Society features a group of young men and women who were interested in French poetry and other literature. The club takes its name from *Le Parnasse Contemporain*, the title of the first collection of poems published in 1866 by a school of French poets. The Parnassian Society continues to be popular at Columbia High School today. (Courtesy Columbia High School.)

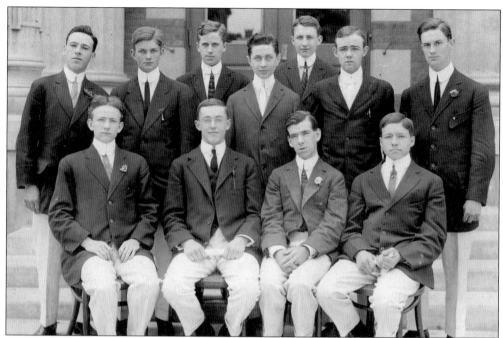

Music, an important element in the development of Columbia High School students, provided a variety of platforms for boys and girls to fine-tune their vocal skills in a group setting. This c. 1906 photograph shows the 11 members of the Boys' Glee Club, some of whom are wearing dress loafers with grosgrain bows. (Courtesy Columbia High School.)

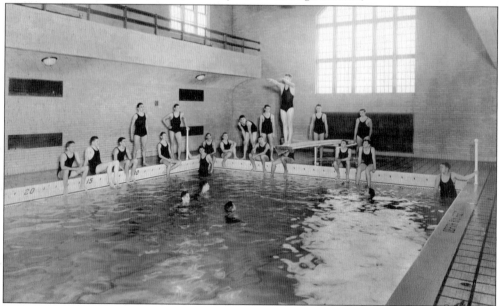

Part of a healthful lifestyle included swimming and, by the 1930s, Columbia High School had its own natatorium, making the school one of just three in the state to have its own swimming pool. Separate swimming classes were offered for boys and girls. The diving board is located at the deep end of the pool, which is noted in tile to be eight and a half feet deep. This pool recently underwent a major restoration. (Courtesy Columbia High School.)

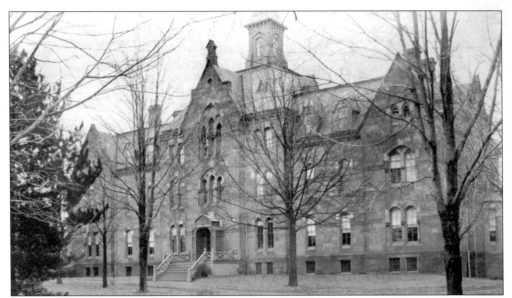

In 1867, Seton Hall erected the administration and college residence building, which is now known as President's Hall and is used as administrative office space. With its leaded-glass windows and extensive warm wood paneling, this building is as impressive on the inside as it is on the outside. The front steps have frequently been used as a gathering place by graduating classes seeking a suitable backdrop for class photographs. (Courtesy Seton Hall University Special Collections and Archives Center.)

In 1899, the chapel at Seton Hall College was one of the most beautiful buildings on campus. Remodeled in 1922, it remains one of the focal points of the university campus and today features a connecting walkway between the chapel and administration building next door. (Courtesy Seton Hall University Special Collections and Archives Center.)

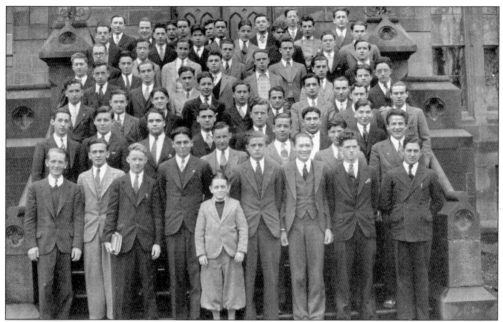

Seton Hall's 1933 graduating class stands on the steps of President's Hall. This wise group of young men includes an exceptional young man wearing knickers. (Courtesy Seton Hall University Special Collections and Archives Center.)

Seton Hall continues to be a source of culture for the South Orange community. In this c. 1956 photograph, Metropolitan Opera stars Lucia Albanese and Jerome Hines flank Msgr. John McNulty. Jerome Hines has been a longtime South Orange resident. (Courtesy Seton Hall University Special Collections and Archives Center.)

Six

NEIGHBORS AND NEIGHBORHOODS

An 1872 advertisement in the *South Orange Bulletin* promoted homes in South Orange for sums ranging from $4,000 to $9,000. The advertisement maintained the notion that the salubrious climate prompted physicians to recommend South Orange as a healthful place to live.

South Orange has always attracted a wide array of residents, many of whom are well known. William A. Brewer Jr., president of the Washington Life Insurance Company in New York City, bought the Old Stone House in 1867 and renamed it Alworth. In 1886, the editor of the *Official Railway Guide*, William Frederick Allen (who perfected and promoted Standard Time), lived on Scotland Road. In 1895, Jonathan A. Monnott, secretary and treasurer of Goodyear Rubber Company, purchased land on Scotland Road. Other well-known residents included Robert Ward, Clarence Riker, Louis Bamberger, Felix Fuld, William E. Lehman, Robert J. Wiss, and Moses Roth. Madeleine Edison (daughter of the famous inventor), the Blanchard family (who often hosted the likes of Joe DiMaggio and Marilyn Monroe), and the Mennen family (founders of the personal care products company of that name) also lived in the village.

In 1920, Paul Starrett, lived on Berkeley Avenue in Montrose Park. Starrett and his five brothers were partners in Thompson-Starrett, one of the largest construction companies in the early 1900s known for its quick construction of tall, monumental buildings, including the Empire State Building. Starrett incorporated a number of unique design elements in his home, including a small version of the heating system used in the Empire State Building.

Today, the proximity of South Orange to New York City makes it an ideal location for commuters. It is home to New York corporate banking and finance executives as well as entertainers, including John Davidson and Lauryn Hill. T.S. Monk and other well-known jazz musicians call South Orange home. Actors James Rebhorn, Andre Braugher, and Ami Brabson also live in South Orange. Sibling actors Elisabeth and Andrew Shue grew up in South Orange. Max Weinstein, drummer for Bruce Springsteen and bandleader of the Conan O'Brien show, spent his formative years in town. Opera star Jerome Hines has resided in South Orange for many years.

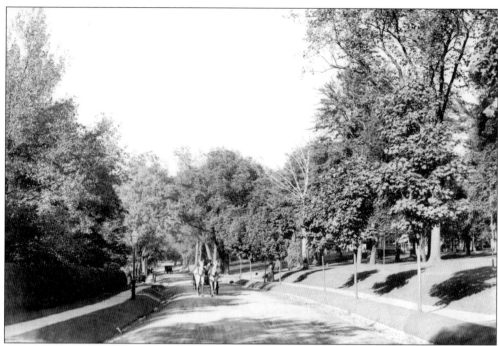

This *c.* 1900 view of Scotland Road speaks of gentler times when the sound of horse hooves on tree-lined, unpaved roads was the only sound heard when carriages passed by. Today, Scotland Road is still a tree-lined thoroughfare with bluestone sidewalks. Although the stone gutters have been preserved on some streets, they have not been maintained on Scotland Road. (Courtesy collections of New Jersey Historical Society.)

This photograph of Janice Crowell Wheeler was taken *c.* 1912 in front of 59 Taylor Place, near Vose Avenue. The young girl is seen here playing dress-up in adult clothes and pushing her dolly in a pram. Since there were no dress-up kits at that time, little girls creatively scoured their mothers' closets. Wheeler seems to have successfully captured the dress code of the time, right down to the requisite bonnet. (Courtesy South Orange Public Library.)

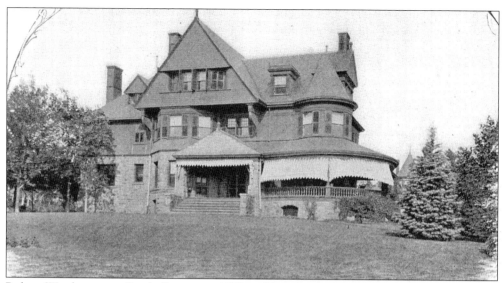

Robert Ward came to South Orange in 1879 and bought three and a half acres on Raymond Avenue, where he built his family home, Rosemont. In 1896, the house was described as a modern English villa. The first story is Belleville red sandstone, with the second and third stories carried out in framework. Ward is credited with manufacturing and introducing Eiderdown cloth, the first knitted flannel piece of goods ever sold in this country and possibly the world.

Located at the foot of Silver Spring on Ridgewood Road, this c. 1906 equine drinking fountain served as a central watering location for thirsty horses. In this summertime view, a horse takes a break from pulling his carriage to quench his thirst with spring water. (Courtesy collections of New Jersey Historical Society.)

Born in 1846, William Frederick Allen achieved a worldwide reputation in his successful efforts to perfect and secure the adoption of the system of Standard Time now in general use throughout much of the world. Allen moved to Ralston Avenue in 1880 and just six years later purchased a plot of ground on Scotland Road, where he built an imposing home in the style described as American Domestic. He later became president of the Meadow Land Society, an organization designed to enhance the value of all surrounding property by its restrictive features. Reportedly, the organization was significant in bringing together the best elements of the village through its membership and that of the club, which occupies a large part of the grounds.

On May 23, 1887, Henry A. Page was elected president of the Essex County Country Club. Page lived on an estate with a gatehouse on Ridgewood Road in Montrose and was a significant contributor to the development of the Montrose area before Montrose became part of South Orange. Following Page's ownership, the home was owned by the Pabst family of the Pabst Brewery. Although the original Page home no longer exists, the stone gatehouse still stands at the corner of Ridgeview Road and Melrose Place.

HENRY A. PAGE,
PRESIDENT.

R. WAYNE PARKER,
TREASURER.

T. H. POWERS FARR,
SECRETARY.

OFFICERS OF COUNTRY CLUB.

The tree-lined walkway on the left crosses the front yard to the Kips-Riker mansion, which was built in 1904. In this scene, a horse-drawn buggy travels north on Scotland Road while a nanny with a pram and a small child take a stroll on this fall afternoon. The early gas lamp is the type that used sperm whale oil. (Courtesy Seton University Special Collections and Archives Center.)

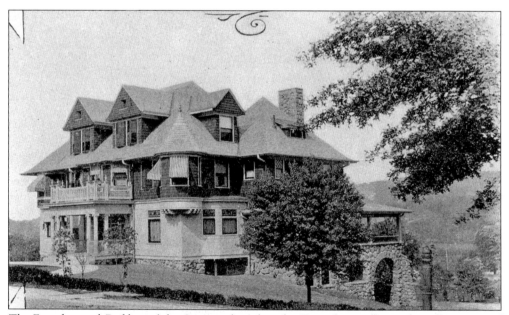

The Founders and Builders of the Oranges describes the Ferris house (located at the corner of Scotland Road and Raymond Avenue and built by architects Rossiter & Wright) as "a modern American house, which would suit the location and grade of land. . . . The rear of the house features a broad veranda from which the Ferris family can view Eagle Rock and Montclair to the north and Milburn and Wyoming on the south."

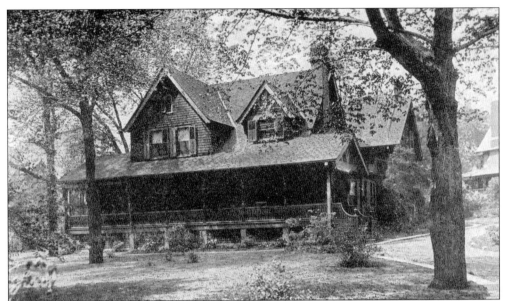

Located at the corner of South Orange Avenue and Grove Road, one of the village's earliest landmarks still stands. It is known as the Old Stone House and was mentioned in documents as early as 1680 in a grant made to Edward and Joseph Riggs and Nathaniel Wheeler. In January 1773, it became the property of Dr. Bethuel Pierson. The property later passed to Cyrus Pierson and then to Moses Lindsley. In 1867, it was purchased by William A. Brewer Jr., who named it Aldworth. Today it is a national landmark and in the process of being restored.

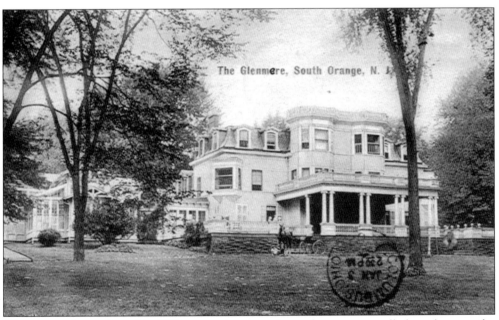

Glenmere is featured on this 1909 postcard and was located on an unusually large lot near the current location of Forest Avenue. On this card, Ida writes to Dory Apgaw in Mendham, New Jersey, "How are you these days? I am at So. Orange with my sister for a few days and having a nice time." (Courtesy Seton University Special Collections and Archives Center.)

92

The palatial Lermanna House once stood at the intersection of Centre Street and South Orange Avenue and became the site of Seton Hall, founded by the first bishop of Newark, James Roosevelt Bayley, in 1856. Seton Hall is the oldest diocesan university in the United States. Bayley named the college after his aunt, Mother Elizabeth Ann Seton, who was a pioneer in the work of Catholic education and the first American-born saint. The existing building was adapted for a seminary, which functioned side-by-side with Seton Hall College. (Courtesy collections of New Jersey Historical Society.)

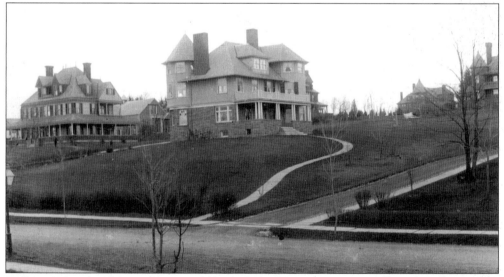

William J. Baird and Anna Grant Baird built this 8-bedroom, 15-room, wood-shingled house at 212 Scotland Road in 1889. The Bairds lived there until August 1941. When Montrose Park was further developed in the 1950s and new roads were paved, the land in front of the house was sold off and the back of the house became the front. The address then changed to 112 Raymond Avenue. Original alabaster shades cover electric wall fixtures. (Courtesy South Orange Public Library.)

Painted wood brightened this living room, which contrasted the natural dark wood that dominates the rest of the main floor. This room featured a fireplace with an Adamesque frieze. Another fur rug was placed in front of the dainty loveseat. (Courtesy South Orange Public Library.)

The parlor was more informal and featured a mounted animal head over the fireplace. All fireplaces in the house were originally coal fired. Double pairs of draperies at the window featured a light fabric closest to the glass that offered privacy. The heavier pair, when pulled across the window, was designed to keep out the cold air. (Courtesy South Orange Public Library.)

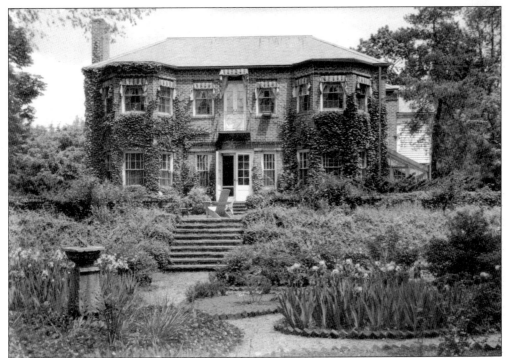

Located in an estate setting at 565 Berkeley Avenue, this two-story, five-bay brick Colonial Revival home was built *c.* 1900. Brick piers inscribed with the word *Holmwood* frame the driveway. This is the former estate of Henry M. Keasbey, who was a pioneer in the fireproofing industry. (Courtesy South Orange Public Library.)

This *c.* 1905 postcard shows a rural view of Ridgewood Road. Evidently speeding automobiles were a concern even then. The sign on the gas lamp advises, "Automobiles please drive slow."

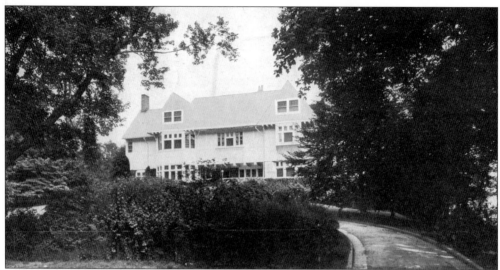

The estate owned by Louis Bamberger was located at 602 Centre Street, where the current Veterans Administration Hospital now stands. The Bamberger department store (now Macy's) was located in Newark, New Jersey, and was one of the major landmarks in the early 1900s. Bamberger donated his land for the Veterans Administration Hospital, which opened in 1952. The Bamberger estate was located at the rear of the property, at the corner of Finlay Place. (Courtesy South Orange Public Library.)

Louis Bamberger lived in South Orange. His huge department store was located in Newark and was one of the major landmarks in the early 1900s. Pictured is the back of one of the store's first credit cards. The front featured a stylized image of the department store. When Bamberger shoppers used their credit card, the sales assistant would just write the card number on the sales slip. Note that there is no signature space or security enhancements used on the card. Each card was delivered with its own cardboard carrying case. (Courtesy Amy Dahn.)

Built in 1895, this Centre Street home was owned by Anna H. Kingman (wife of Thomas S. Kingman). The house is similar in style to the home Kingman built for himself at the corner of Montrose Avenue and Centre Street (now the Seton Hall University Ring Building) and is an example of eclectic late-Victorian architecture. Elements of the Tudor, Shingle, and Stick styles are present. By 1896, the house was sold to John W. Combs, a Newark executive. Legend has it that the home was designed by Stanford White, who was known to design houses for friends and associates. (Courtesy South Orange Public Library.)

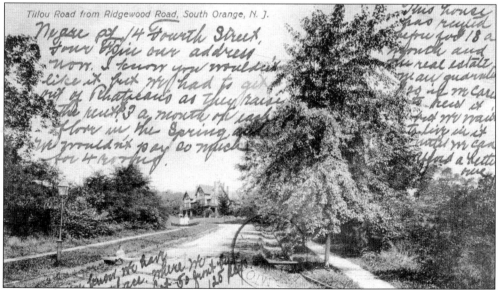

This postcard, sent in 1908 to Mrs. Moffatt in Binghamton, New York, reads, "Dear Aunt Serna: I suppose you know we have moved. We are only 4 blocks from the South Orange Station and 3 houses from the railroad and have racket all night but still does not annoy us as did those children of Wilson's. Have the whole house to ourselves. Has 8 rooms so I am busy all the time. Hope you can come down this year. . . . Love to all, Edith." The note on the front says they could rent the house for $20 a month if they decide to move to a better house later. (Courtesy Seton Hall University Special Collections and Archives Center.)

STERLING ROSS

NEWARK *Newsreel*

VOL. 2 JANUARY-FEBRUARY, 1947 No. 4

Born in 1863, Clarence Riker was an explorer and drug manufacturer whose ancestors owned large tracts in New York and Long Island, including Rikers Island. His early business associations included one with the Booth Steamship Line, which in 1886 operated on Brazil's Amazon River. His trips to Brazil yielded the discovery and collection of 22 new species of birds. His collection of 10,000 butterflies now resides in a Colorado museum; his collection of hundreds of birds from all over the world resides in the Smithsonian in Washington, D.C. Riker was a life member of the Museum of Natural History and, as a result of his explorations, became a life member of the Explorers Club, which has included such outstanding men as Pres. Theodore Roosevelt and Adm. Robert Peary. In 1891, Riker founded the Sydney Ross Company with F.L. Upjohn. Riker served as president of the company, which became the largest drug manufacturer and distributor of medicinal products in Latin America. Riker was known as one of South Orange's best figure skaters and, for nearly 30 years, was known to go horseback riding every morning before breakfast. His favorite sport, however, was freshwater fishing. In World War I, Riker was a leader in the local security organization, the Home Guard of South Orange, which he equipped at his own expense. (Courtesy Carleton B. Riker Jr.)

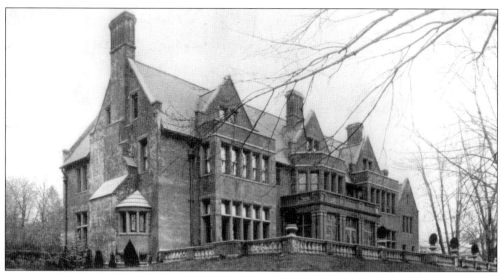

This 1904 photograph of the Ira A. Kip Jr. house at 432 Scotland Road at the corner of Montrose Avenue was named Montrose. The house was sold to Clarence Bayley Riker in 1912. In a letter dated February 7, 1933, to Daniel Riker, Kip writes, "I bought this property . . . in 1900 for $27,000. I selected Henry Ives Cob of New York and Chicago, one of the best architects in the country for the English type of house. I had as contractors, Heddon & Company of Newark, New Jersey. The house cost me to build and decorate something over $100,000. . . . The gargoyles in the Billiard room, I copied from figures in the front of the church in Dijon, France." The home features a stained-glass window depicting knights of the Fifth Crusade receiving the blessings of Louis IX of France. Today, the mansion is the home of Temple Sharey Tefilo-Israel. (Courtesy Carleton B. Riker Jr.)

The Kip-Riker mansion, at 432 Scotland Road, was the scene of many social gatherings, in particular a dance, which was the subject of a report published in the Suburban Society in March 1916, highlighting the elegance of the home and the event. The great hall at Montrose features stained-glass windows, a wood Venetian chandelier, and a fireplace that features a carved wooden frieze of Roman battle scenes. This fireplace is copied from a castle on the Rhine River in Germany, and George W. Vanderbilt owned a copy. The tapestry-lined dining room boasts a fireplace with two carved oak herculean figures that support the hand-hewn oak mantle. The frieze is Mexican onyx. (Courtesy Carleton B. Riker Jr.)

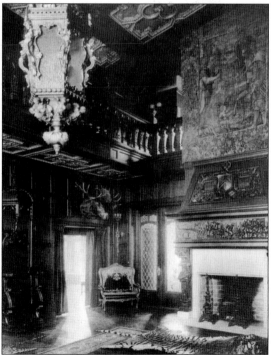

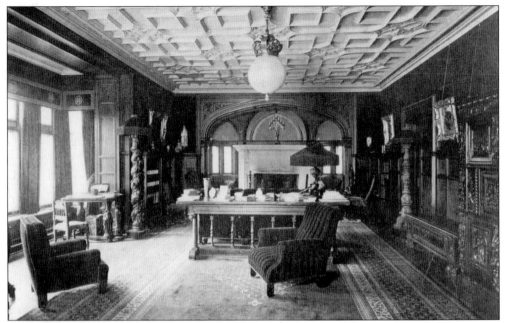

This 1904 photograph that appeared in *Architecture* magazine features the library located on the Montrose Avenue side of the house. It was known as the Italian room. A crystal globe chandelier hangs from the English coffered ceiling. Today, Temple Sharey Tefilo-Israel uses the library as its chapel and it remains relatively unchanged. (Courtesy Carleton B. Riker Jr.)

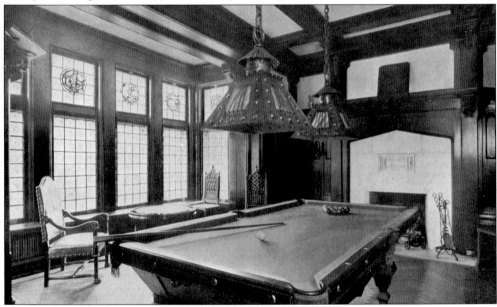

Another photograph from the same issue of *Architecture* features the billiard room, located at the rear of the house. Over the fireplace is the Scottish phrase "East West Hames Best," or the more familiar "East or West, Home is Best." The billiard room was the daily living space for the Rikers. Carleton Riker Jr. remembers spending time with his grandparent in that room, reading or tuning in the radio. The telephone was a short walk around the corner to the hall, near the kitchen. (Courtesy Carleton B. Riker Jr.)

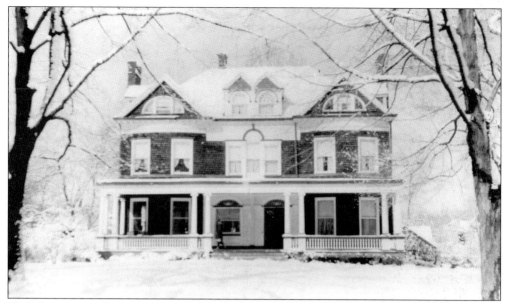

Well known in the area to sweet-toothed connoisseurs, the Martha Washington Candy Company was owned by the Vanderkeifs, who lived at 413 Centre Street. Before the Great Depression, this was a 29-store chain that included a store in South Orange. Financial reversals impacted the company. After the Great Depression, there were about seven stores. (Courtesy Rachelle Christie.)

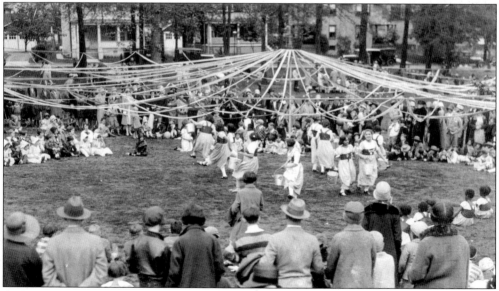

An appreciation for open space was important even at the beginning of the 20th century. In 1908 (as noted in Pierson's *History of the Oranges*), "several wide-awake citizens purchased five acres of unimproved landed . . . for $8,000. An additional $2,000 was spent to convert the wild land into a beautiful breathing space." As early as the 1920s, the park was the site of annual events and festivals. For the last 50 years, it has been a playground. (Courtesy collections of New Jersey Historical Society.)

Although South Orange was an established, social, and upwardly mobile community by the early 1920s, it was not uncommon to raise chickens and goats on one's property. Raising vegetables and chickens for eggs became particularly popular during the world wars, when residents were encouraged to tend victory gardens. This 1921 photograph shows two-year-old Carleton Riker Jr. in the chicken coop. (Courtesy Carleton B. Riker Jr.)

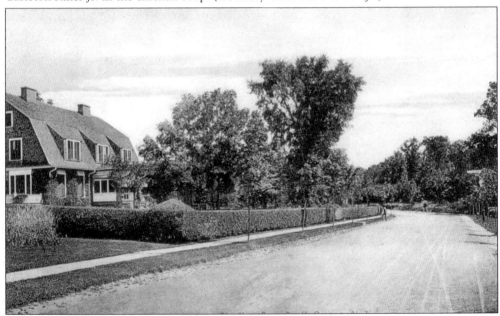

This early-20th-century postcard shows a dirt road that reveals where several carriages have traveled on tree-lined Charlton Road. Rock-lined gutters, bluestone sidewalks, and a Colonial house await guests behind a manicured hedge. Charlton Road is located in the Montrose Park section of South Orange. (Courtesy Seton Hall University Special Collections and Archives Center.)

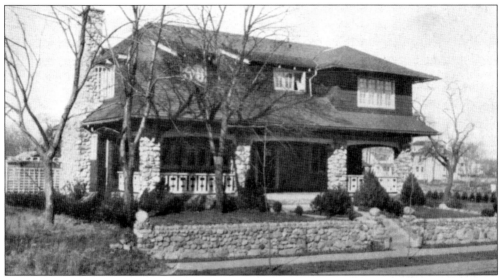

This Tuxedo Park home on Synott Place is included in a 1914 real estate brochure. Tuxedo Park, a new neighborhood bordered by South Orange Avenue and Seton Hall University, was promoted as an exclusive neighborhood of single-family homes with distinctive features and space restrictions designed to protect the air and light of every owner. Prices for each property ranged from $1,400 to $4,200, depending upon the size of the lot. (Courtesy Ford and Geri Livengood.)

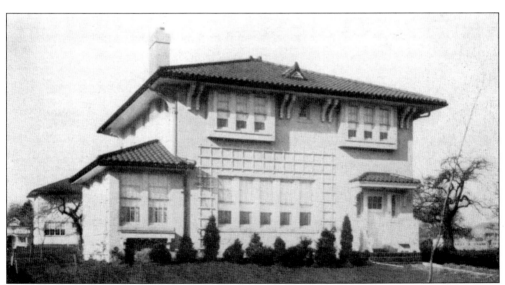

Featured in the same 1914 real estate brochure, this red-tile-roofed home in Tuxedo Park is touted for its location near bustling Newark but within walking distance of the South Orange Lackawanna Station, which offers 50 trains each day and can transport commuters to New York City in 34 minutes. (Courtesy Ford and Geri Livengood.)

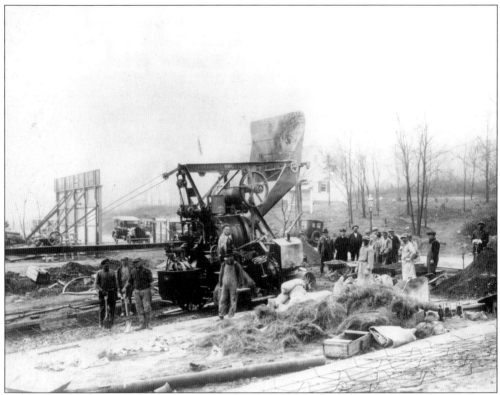

In the late 19th and early 20th centuries, South Orange was an expanding community and new neighborhoods and roads were being developed at a fairly rapid rate. This *c.* 1930 photograph shows a Koehring paver working on the installation of Glenview Road in the Newstead section, using George Turrell's money-saving system. (Courtesy Roy Scott.)

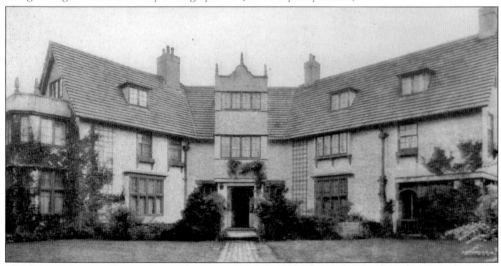

The M.J. Currie residence, shown in this 1923 photograph, is located on Charlton Avenue. At one time, it was the home of two sisters who had a serious altercation and subsequently decided to divide the house in half. A center section of the house was removed, effectively creating two buildings next door to one another. (Courtesy South Orange Public Library.)

In the early 1920s, it was not uncommon for an entrepreneurial individual to bring a pony around the neighborhood for the children to ride and for their parents to photograph them. Three-year-old Carleton B. Riker Jr. sits atop the pony in the driveway at 432 Scotland Road. (Courtesy Carleton B. Riker Jr.)

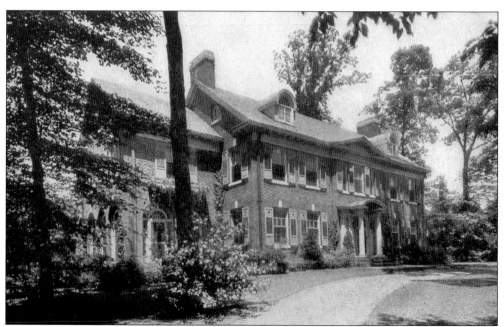

In 1923, this was the stately Berkeley Avenue residence of George N. Wilson. This section of Berkeley Avenue is located in the Montrose Park Historic District.

A dump truck receives gravel at Kernan's Quarry in this 1940 photograph. Kernan's Quarry was one of two quarries that existed in South Orange. The other quarry, Lepre's, was formerly at the top of South Orange Avenue. Kernan's Quarry is inactive. (Courtesy Rose and Joe Zuzuro.)

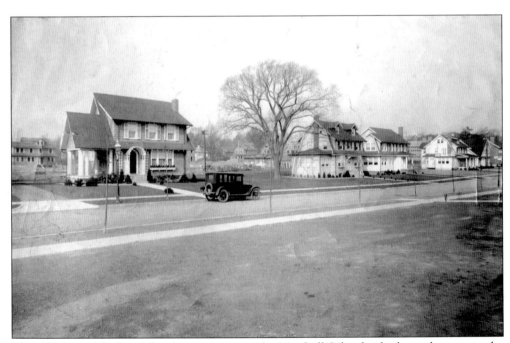

This 1920s neighborhood development is near the Marshall School, which can be seen in the background. The school was built in 1922. (Courtesy Anthony Vecchione.)

SCOTLAND ROAD, RESIDENTIAL DISTRICT SOUTH ORANGE, N. J.

This bucolic 1920s view of Scotland Road looks much the same as it does today, with the minor evolution of automobile styles. (Courtesy South Orange Public Library.)

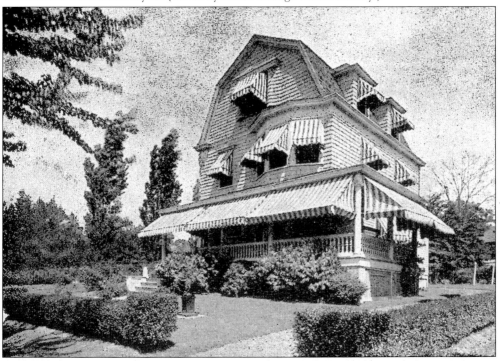

Located nearby Seton Hall University, Riggs Place is a neighborhood of a variety of Shingle, brick, and wood homes. This Shingle-influenced home was the residence of David J. Lewis Jr. in the early 1920s. (Courtesy South Orange Public Library.)

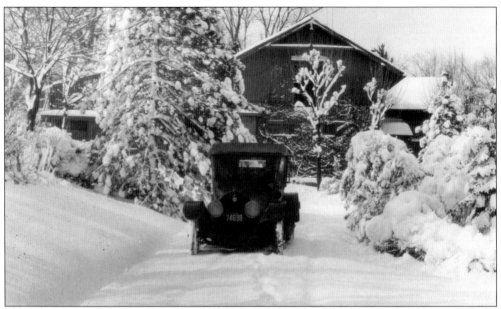

This 1926 photograph, taken at 432 Scotland Road, shows one of the earliest Ford automobiles before the invention of the snow tire. (Courtesy Carleton B. Riker.)

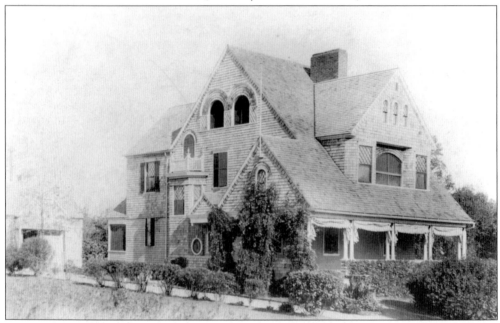

Located in the Montrose Park district, this house was built in 1900 for T. Spencer Miller, who perfected a cable carrier system that made it possible to deliver heavy loads over long distances. One of his cableways was used in the construction of Hoover Dam. His invention of the button stop fall rope carrier was an instant success. He later became assistant secretary of labor under Pres. Dwight D. Eisenhower. Miller's son, Spencer Miller Jr., was the state highway commissioner under whom the Garden State Parkway was developed. He also worked with national garden clubs to establish Blue Star Highway planted medians in honor of World War II veterans. (Courtesy Rayna Pomper.)

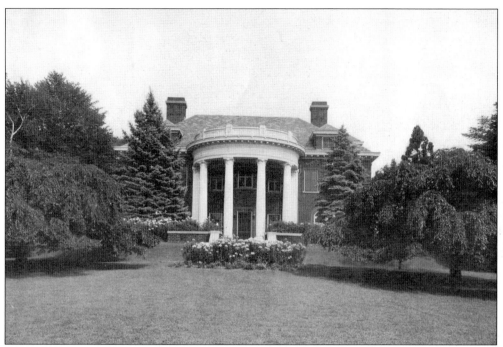

Built *c.* 1920, this Neoclassical brick house was home to Walter Steifel, a chemical manufacturer. Steifel lived here for several years, during which he contributed to the military effort by making munitions. (South Orange and Maplewood in Pictures.)

Looking east on Raymond Avenue from Charlton, this *c.* 1910 postcard shows an extant home in a rural setting. While Raymond Avenue features more homes today, the aesthetics shown in this view are still intact. (Courtesy Seton Hall University Special Collections and Archives Center.)

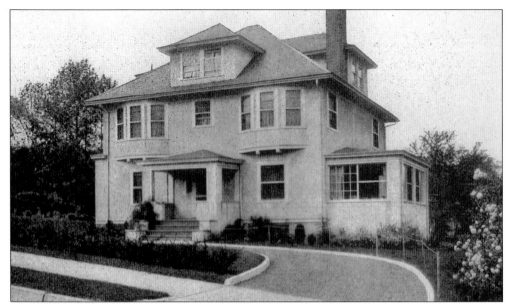

This photograph features the *c.* 1920 Glenside Road home of George H. Finlay, built in what is now considered the Mountain section of South Orange. In the mid-19th century, the Mountain House Spa was located near what is now considered Glenside Road. Glenside Road may have been part of the original roadway to the spa. (Courtesy Seton Hall University Special Collections and Archives Center.)

Known in the 1930s, 1940s, and 1950s as Little Italy, the Church Street neighborhood featured modest houses that were home to skilled trades people such as masons, carpenters, and even midwives. More than 100 young men from this neighborhood alone answered their call to action during World War II. This group poses *c.* 1953 with two favorite dogs. In the front row on the far left is Carmen Iontasco. Next to him is Donald Giordano, who was killed while serving in Korea. (Courtesy Rosa and Joe Zuzuro.)

This 1925 photograph shows six-year-old Carleton B. Riker Jr. dressed in short pants and carrying a 48-star flag. (Courtesy Carleton B. Riker Jr.)

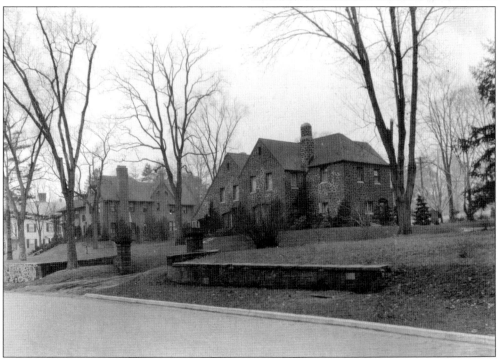

This photograph of North Ridgewood Road was taken in the early 1920s and shows the street, which is still cobbled. (Courtesy Roy Scott.)

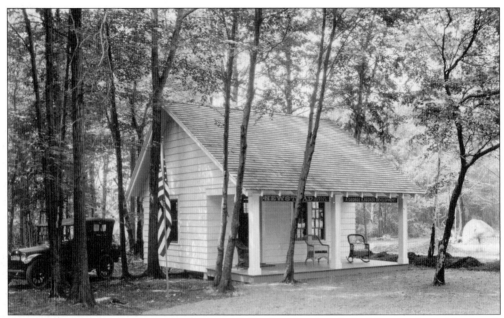

In the late 1920s and early 1930s, George H. Becker developed the Newstead neighborhood, located on the west side of town. This photograph shows the realtor's field office that was built on Glenview to sell the homes. The rocking chair and the late-1920s automobile convey the comfortable lifestyle offered in the Newstead neighborhood. (Courtesy Roy Scott.)

FIELDING COURT SOUTH ORANGE, N. J.

Fielding Court was developed in the 1920s and features cozy homes just right for new families. These houses are representative examples of Colonial and Dutch Colonial–style homes. (Courtesy Seton Hall University Special Collections and Archives Center.)

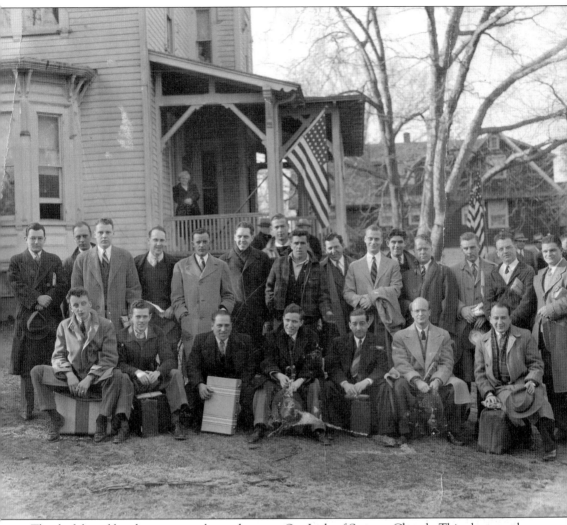

The draft board headquarters was located next to Our Lady of Sorrows Church. This photograph shows World War II recruits who have signed up to serve their country. Sitting with their luggage, these young men wait to be transported to various destinations. Included in the photograph are Russell "Tootsie" Verduci (center, in the plaid coat), who later became a police officer; Lou Magliaro (to the right of Verduci, with striped tie); Luigi Mercadante (front row, third from the left); and Tony Zuzaro (front row, far right). (Courtesy Rose and Joe Zuzuro.)

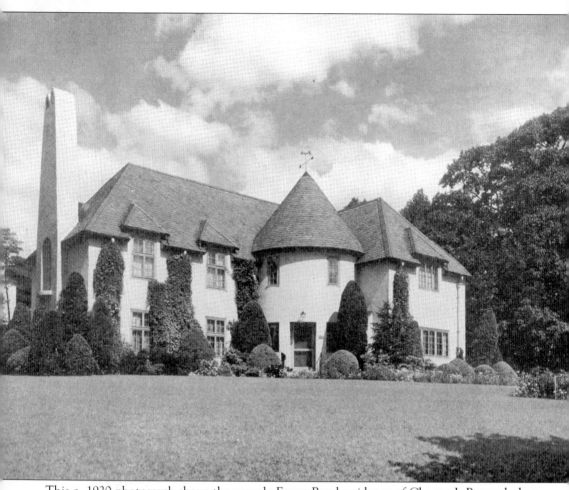

This c. 1920 photograph shows the upscale Forest Road residence of Chester I. Barnard, then president of New Jersey Bell Telephone Company. (Courtesy South Orange Public Library.)

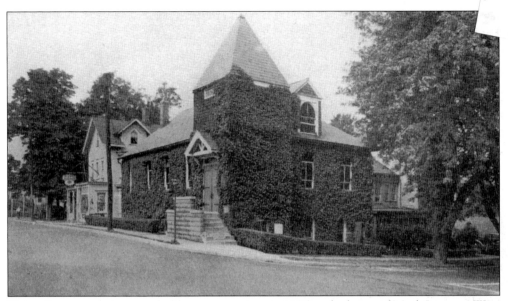

Thirty-five men and women held prayer meetings in 1895 at the home of Mack Jones on West South Orange Avenue. In 1898, a congregation was formally organized. The next year, the church was incorporated. In 1908, for the sum of $1, Mr. and Mrs. Jordan Moran deeded property at Second and Valley Streets to the congregation to build a church. Funds were raised and, on November 24, 1913, the First Baptist Church was dedicated. In the 1950s, Sr. Mamie Rodman willed her estate to the First Baptist Church and four years later a constitution was adopted. An active congregation continues to worship in this church today. (Courtesy First Baptist Church.)

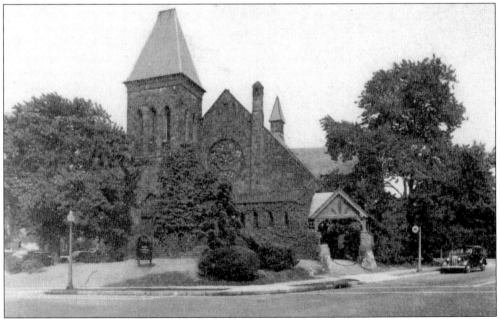

In 1831–1832, the first village church was organized as the First Presbyterian Church of South Orange. In 1843, the congregation occupied a wooden structure, and then this stone church was built at 111 Irvington Avenue. (Courtesy South Orange Public Library.)

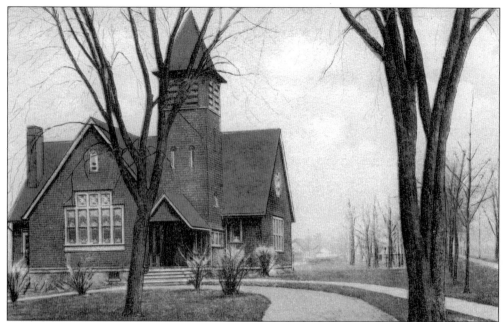

Grove Park was selected for the location for Trinity Presbyterian Church when a splinter group formed its own congregation in 1892. In 1935, the two congregations reunited. This building no longer exists. (Courtesy Seton Hall University Special Collections and Archives Center.)

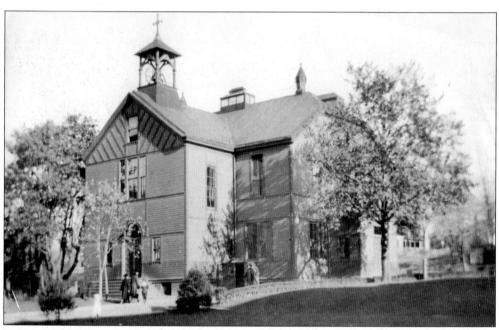

In June 1878, it was decided that a parish and parish church should be built in South Orange. Articles of incorporation were signed on January 1, 1887. A loan from Seton Hall helped finance the erection of the brick, stone, and wood structure, which was projected to cost $8,000. The school opened in 1891, and a rectory was completed. (Courtesy Our Lady of Sorrows Parish.)

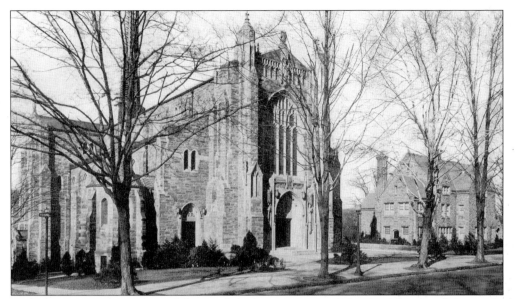

Both the town and members of the parish had grown since 1878, when the church began. In 1931, the new church at 271 Prospect Street was dedicated. Designed in the French Gothic style, the building cost approximately $600,000. In keeping with the general design of Gothic churches, the church is cruciform in shape. The walls consist of three layers of masonry with an exterior of Foxcroft stone from Pennsylvania. The roof is supported by a system of steel trusses above a vaulted ceiling, and the floor is reinforced concrete covered by linoleum and marble. It seats 1,000 people. (Courtesy Our Lady of Sorrows Parish.)

This 1921 photograph shows the groundbreaking ceremony for Our Lady of Sorrows School. Parish children watch as Monsignors Grady and Coyle and Peter S. Smith turn over the ground for their new school. (Courtesy Our Lady of Sorrows Parish.)

THE OHEB SHALOM FAMILY

A BRIEF HISTORY

In the fall of 1860, twelve years after the founding of Newark's B'nai Jeshurun, whose services were now being conducted in the newly developing Reform manner common to many congregations of German origin, a group of disgruntled members decided to form a new synagogue with more traditional religious practices. Thus at a meeting at the Prince Street home of B'nai Jeshurun's former president, Bernard Hauser, was born a congregation to be called Oheb Shalom, "lovers of peace," with Rabbi Isaac Schwarz, the first rabbi at B'nai Jeshurun, now becoming the first rabbi at Oheb Shalom. Orthodox services were conducted in Hebrew and German on the top floor of a Prince Street dwelling with women occupying the balcony and men wearing high silk hats. Dues were thirty-six cents per month.

Even in those days the vision of Oheb Shalom was broad, far beyond the recitation of prayers. Of prime importance was the school whose volunteer teachers were required to be competent, and whose principal was a highly trained person who usually led prayer services. In 1866 the congregation began to operate a cemetery on a site that still exists on South Orange Avenue in Newark. A women's auxiliary, Miriam Frauen Verlein, was formed in 1880, an idea initiated by Rabbi Tintner who came to the steadily growing congregation in the late 1870's. The congregation built a new brick structure on the east side of Prince Street which has been designated a state historic landmark. In this new building

Congregation Oheb Shalom has come a long way from its early Newark roots in the 1870s, when the congregation built its structure on Prince Street in Newark. Men and women began to sit together. The congregation gave up German as its official language, adopted the Jastrow Prayer Book, and installed an organ. By the beginning of the 20th century, the majority of congregation members were American-born and the character of Oheb Shalom embraced new styles, practices, and rituals. In the early 1940s, the congregation acquired property at 170 Scotland Road, and a contemporary building was carefully erected so that the silver birch tree could be saved. Today, Oheb Shalom continues to grow and serve its congregation from its synagogue in South Orange. (Courtesy Oheb Shalom.)

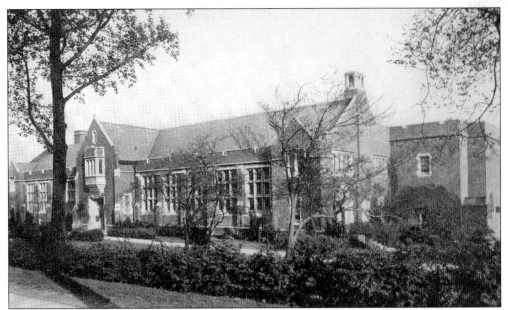

Located in the West End neighborhood of South Orange (then called South Orange Ridge), the South Mountain School was built in 1929 to serve as a neighborhood school for kindergarten through grade six. South Mountain was the fourth school building to be built in the 1920s and represents part of the $3.5 million expenditure to build the new schools. (Courtesy South Orange Public Library.)

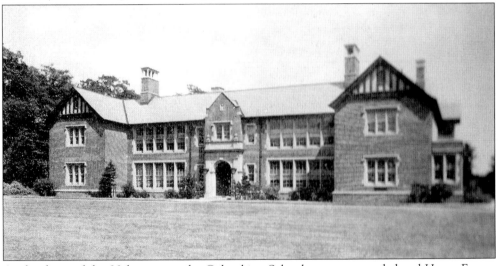

At the dawn of the 20th century, the Columbian School was overcrowded and Henry Foster, superintendent of schools, recommended that the school system be divided into elementary, junior high, and high school divisions. The Marshall School (named for James Marshall, member of the board of education, and located in the Montrose Park neighborhood) was the first elementary school to be built in South Orange. It opened its doors in the fall of 1922 with 11 classrooms for kindergarten through grade six. An addition in the mid-1950s increased its size to 15 classrooms. A second addition took place in the mid-1990s, and a third is currently under way. Today, Marshall School is home to students in kindergarten through grade two. (Courtesy South Orange Public Library.)

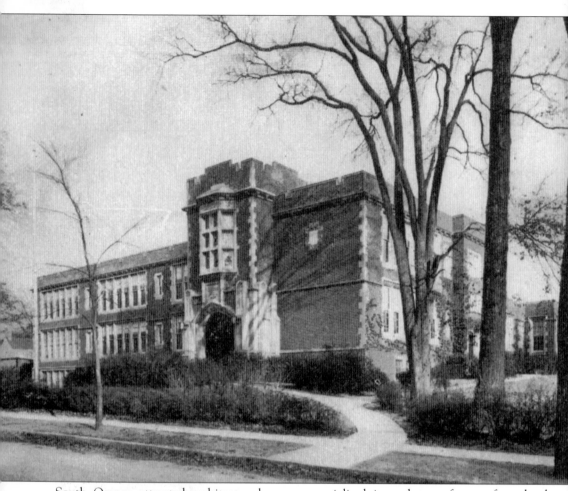

South Orange attracted architects who were specialized in and were famous for school architecture. The 1920s expansion in school buildings illustrates the care and resources put forth in building schools. Built in 1924, the Montrose School is located in the Meadowlands neighborhood. Its imposing structure mirrors the other four schools built in South Orange between 1922 and 1929. (Courtesy South Orange Public Library.)

Shortly after he arrived in South Orange *c.* 1873, George Timson, a small boy at the time, met with an unfortunate accident and lost his sight in both eyes. His cheerful disposition endeared him to longtime residents, and he was the best-known man in town. He made his way through the streets unassisted and earned his own living by pumping water from cisterns to tanks in the attics of houses. The arrival of city water eliminated the need for his services, but he capitalized on his affinity for horses and got work caring for them. By 1927, Timson (who lived on Church Street) could be seen on South Orange Avenue, playing his accordion modestly in some recess with a small cup placed unobtrusively beside him. (Courtesy South Orange Public Library.)

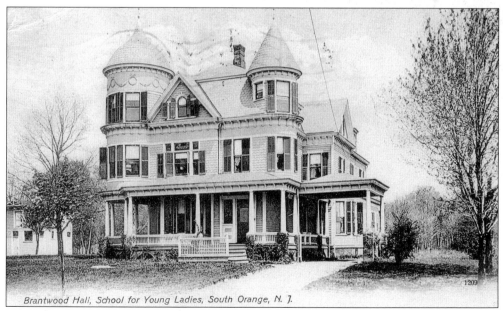

Brantwood Hall, School for Young Ladies, South Orange, N. J.

Located on Warwick Avenue, Brantwood Hall was a finishing school for young ladies who were destined for local society circles. The school is featured in this *c.* 1905 postcard with a beautiful wraparound porch. Today, Brantwood Hall is a private residence that is being restored. (Courtesy Seton Hall University Special Collections and Archives Center.)

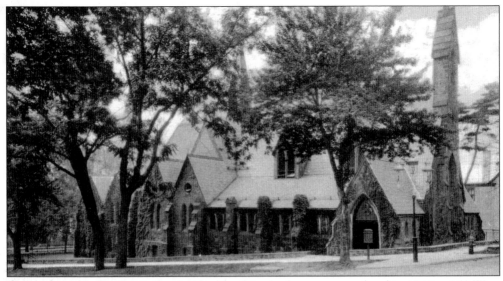

This original Gothic Revival–style Church of St. Andrew was completed in 1960 at 160 West South Orange Avenue. It was originally built to accommodate 150 worshippers. Transepts were added in 1975; two aisles and vestibules were added in 1892, which provided seating for an additional 300 people. Church rector Rev. Lewis Cameron served from 1895 to 1909. Cameron was nationally recognized for his efforts to eradicate the mosquito menace of the time. As part of that campaign, he promoted the practice of pouring oil and draining stagnant waters in the village. Cameron, a sports enthusiast, donated land to serve as a free playground for all village residents. (Courtesy Church of St. Andrew.)

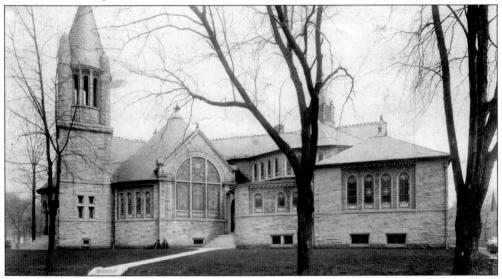

Rev. C.E. Van Cleve organized the first South Orange Methodist class. Two years later, rough seating planks were placed in the village green, across from the village hall, for summer church meetings. By 1853, membership in the congregation ballooned from 24 to 75. The Civil War took its toll; since all the men in the congregation served in the Union army, active members consisted of women and young boys. The extant building, shown in this photograph, was dedicated in 1902 and built for a growing congregation. In 1998, it celebrated 150 years as a multicultural diverse blend of followers.

In the mid-1940s, a group of South Orange and Maplewood residents met in a private home to discuss the organization of a new Jewish congregation that would enable them to come together and worship in their own community. Over a two-year period, the group worked toward building a membership, establishing officers, and selecting a name for the congregation. The name Beth El was chosen, and the first membership included 40 families. In September 1958, Temple Beth El dedicated its new sanctuary and, in 1971, celebrated its 25th anniversary as the center of Jewish activity in the community. (Courtesy Temple Beth El.)

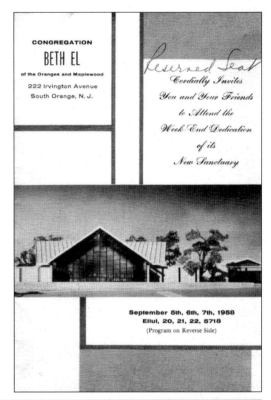

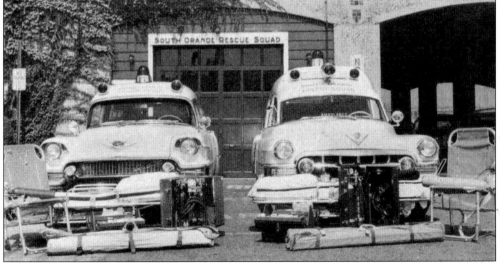

The South Orange Rescue Squad was organized on February 1, 1952, as a nonprofit organization to render first aid to the sick, injured, or disabled. The squad serves the community in medical emergencies and provides transportation between home and hospital. In January 1952, a board of trustees was selected. The next month, a four-patient Cadillac ambulance was delivered. Limited service began on Labor Day 1952 and expanded into a 24-hour service on January 1, 1953. Regular service for the squad included positioning an ambulance at all Columbia High School and Seton Hall home football games. By 1960, the South Orange Rescue Squad had responded to nearly 2,500 calls. (Courtesy South Orange Public Library.)

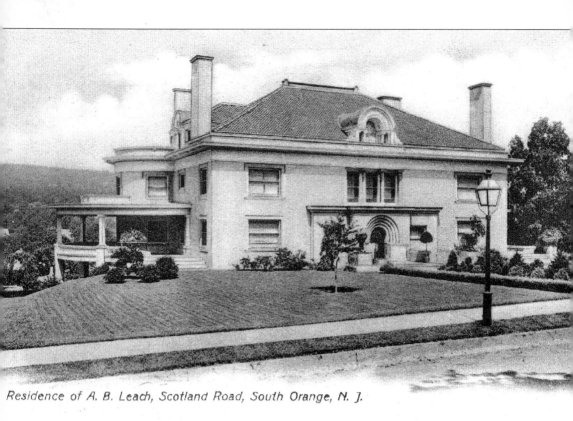

Residence of A. B. Leach, Scotland Road, South Orange, N. J.

Noted Prairie School architect George W. Maher designed the unique *c.* 1901 home of A.B. Leach, shown in this postcard. The Leach house was located on Scotland Road and reflects Maher's criteria for architectural design, about which he said in 1887, "A house should have massiveness and solidity in order to express the idea of substantiality." Maher settled in Kenilworth, Illinois, where much of his work remains today. (Courtesy Seton Hall University Special Collections and Archives Center.)

Shown in this c. 1955 photograph is American Legion Post 220, honoring veterans in a Memorial Day parade. The brass plaque was mounted on a boulder in Cameron Field to remind South Orange residents of those who served their country. Resident Pete Connors, who received the Congressional Medal of Honor c. 1950, is named on this plaque. Cmdr. John DeMichaele, Jimmy Romano, and Vince Nardone are featured in this photograph. (Courtesy Rose and Joe Zuzuro.)

Over the years, renowned architects have been attracted to properties in South Orange. Modern architect Marcel Breuer designed the Cohen House (1974), which stands on Highland Road in the Mountain neighborhood. This design presents a unique blend with the century-old Victorian styles of architecture such as Queen Anne, Stick, Tudor, and Colonial Revival. (Courtesy Amy Dahn.)

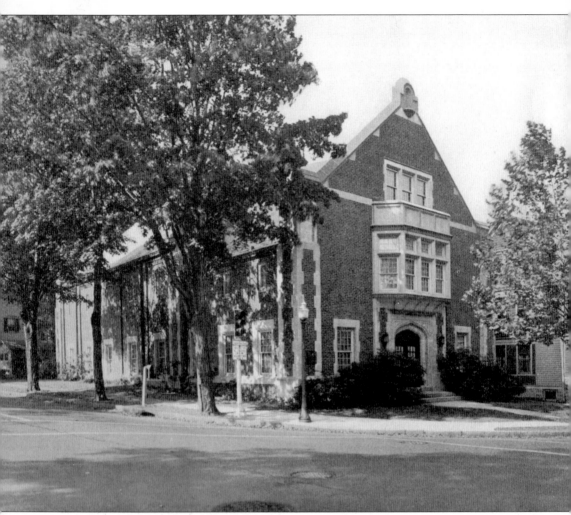

Century Lodge 100, a Masonic lodge, was founded locally in 1869 with eight charter members. They were Daniel Clark, Joseph W. Wildey, A.A. Ransom, Charles E. Lum, Benjamin L. Chandler, David B. Muchmore, William Sprigg, and Daniel Squier. The organization grew and bought the building on Academy Street. Early records show that the building began using gas in 1892 and, on June 20, 1899, L. Bamberger sold them fans for $1.62 apiece. In 1918, the Century Lodge was closed during the months of October and November due to the rampant spread of the influenza epidemic, which discontinued group gatherings. In 1930, membership reached an all-time high of 596, but it declined until 1945. In 1970, the Century Lodge celebrated is 100th anniversary.

BIBLIOGRAPHY

Arlean, Hale Lambert. *Through the Years at Marshall School*. South Orange, New Jersey: Marshall School, 1992.

Bayes, T.P. *Orange Directory*. Orange, New Jersey: T.P Bayes, various volumes, 1908–1970.

Brooks, H. Allen. "The Prairie School in the History of Architecture." *Rassegna*, Vol. 20, No. 74, pp. 16–31. 1998.

———. "The Western Architect: The Voice of the Prairie School." *Rassegna*, Vol. 20, No. 73, pp. 76–109. 1998.

Columbia High School Alumni Directory. Norfolk, Virginia: Bernard C. Harris Publishing Company, 1994.

Fonler, T. *Bird's Eye View of South Orange, New Jersey*. Milwaukee, Wisconson: D. Brenner & Company, 1887.

Foster, H. *The Evolution of the School District of South Orange and Maplewood New Jersey*. Geneva, New York: the W.F. Humphrey Press, 1930.

Herman, B. *The Trail of the Upland Plantations*. Union, New Jersey: Worrall Publications, 1976.

Hughes, T. *View of South Orange, NJ*. New York: Thomas J. Hughes, 1904.

League of Women Voters of South Orange. *Village of South Orange, New Jersey*. South Orange, New Jersey: League of Women Voters, 1960.

Mueller, A. *Atlas of the Oranges, Essex County, New Jersey*. Philadelphia, Pennsylvania: A.H. Mueller, 1911.

"South Orange, 1869–1969. A supplement to the News Record of Mapewood and South Orange." *News Record*. October 2, 1969.

"South Orange, Then and Now. A supplement to the News Record of Mapewood and South Orange." *News Record*. October 20, 1994.

The Telephone (Old and New) in South Orange and Maplewood. New Jersey: New Jersey Bell Telephone, 1939.

Pierson, D. *History of the Oranges to 1921*. New York: Lewis Historical Publishing Company, 1922.

Seton Hall University. *The Summit of a Century: The Centennial Story of Seton Hall University, 1856–1956*. South Orange, New Jersey: Seton Hall University, 1956.

Shaw, W. *History of Essex and Hudson Counties, New Jersey*. Newark, New Jersey: Everts and Peck, 1884.

South Orange Bulletin, various issues.

"Village of South Orange: Gems of the Oranges." *News Record.* 1922.

Taber, T. *The Delaware, Lackawanna & Western Railroad in the Nineteenth Century 1828–1899.* Muncy, Pennsylvania: Thomas T. Taber III, 1977.

———. *The Delaware, Lackawanna & Western Railroad in the Twentieth Century (History and Operation) 1899–1960.* Muncy, Pennsylvania: Thomas T. Taber III, 1980.

———. *The Delaware, Lackawanna & Western Railroad in the Twentieth Century 1899–1960.* Muncy, Pennsylvania: Thomas T. Taber III, 1981.

Township of South Orange. *Illuminating South Orange.* South Orange, New Jersey: Township of South Orange, 2001.

Whittemore, H. *The Founders and Builders of the Oranges.* Newark, New Jersey: I.J. Hardham, 1896.

Zakalak Associates *Cultural Resources Survey of Essex County, New Jersey.* Essex County, New Jersey: County of Essex, Department of Planning and Economic Development, 1986

Zakalak Associates. *Montrose Park Historic District, South Orange, New Jersey Nomination to the National Register of Historic Places.* U.S. Department of the Interior National Park Service, 1997.